D0505000

Editing, Storing and Sharing your Digital Photographs

Prentice Hall
is an imprint of

Harlow, England • London • New York • B⸱ ⸱ong
Tokyo • Seoul • Taipei • New Delhi • Cape Milan

PEARSON EDUCATION LIMITED

Edinburgh Gate
Harlow CM20 2JE
Tel: +44 (0)1279 623623
Fax: +44 (0)1279 431059
Website: www.pearsoned.co.uk

First published in Great Britain in 2011

Pearson Education is not responsible for the content of third-party Internet sites.

ISBN: 978-0-273-74414-6

British Library Cataloguing-in-Publication Data
A catalogue record for this book is available from the British Library

Library of Congress Cataloging-in-Publication Data
A catalog record for this book is available from the Library of Congress

10 9 8 7 6 5 4 3 2 1
15 14 13 12 11

Designed by pentacorbig, High Wycombe
Typeset in 11/14 pt ITC Stone Sans by 3
Printed in Great Britain by Scotprint, Haddington.

Editing, Storing and Sharing your Digital Photographs

in Simple steps

Louis Benjamin

Use your computer with confidence

Get to grips with practical computing tasks with minimal time, fuss and bother.

In Simple Steps guides guarantee immediate results. They tell you everything you need to know on a specific application; from the most essential tasks to master, to every activity you'll want to accomplish, through to solving the most common problems you'll encounter.

Helpful features

To build your confidence and help you to get the most out of your iPad, practical hints, tips and shortcuts feature on every page:

ALERT: Explains and provides practical solutions to the most commonly encountered problems

HOT TIP: Time and effort saving shortcuts

SEE ALSO: Points you to other related tasks and information

DID YOU KNOW? Additional features to explore

WHAT DOES THIS MEAN?
Jargon and technical terms explained in plain English

Practical. Simple. Fast.

in Simple steps

Dedication:

To Denise – infinite power supply for my creative exploits.

Acknowledgements:

Thanks to my friends, students and fellow faculty at ICP, who challenge and inspire me. Per Gylfe and Bradly Treadaway have always been great sounding boards; I am grateful. Special thanks to Eugene Foster, who brought me into the ranks of the ICP faculty.

Dan, Duval and Brian kept me supplied with 'go-juice' and community at critical moments, and even saved my bacon when my computer went on the fritz. The Coffee Shoppe is my home away from home. Thanks to Michael Lowe for your thoughtful ear and for introducing me to Carbon Copy Cloner.

Dr Neil – you do an amazing rain dance. Thanks also to Steve Temblett, Katy Robinson, Michelle Clark and the Pearson Education team for your stewardship and assistance in putting this book together.

Finally, Mom and Dad gave me a great start in life, fed my curiosity and bought a lot of my cameras. You wouldn't be holding this book if it weren't for them.

Publisher's acknowledgements

We are grateful to the following for permission to reproduce copyright material:

Screenshots
Page 15 from EU Copyright Office, Copyright © EU Copyright Office; pages 19, 30, 104 from Google Maps; pages 30, 49, 77, 103, 104, 112, 114, 115, 116 from Picasa; page 59 from Apple Inc., Screenshot reprinted with permission from Apple Inc.; pages 62, 63, 64, 66, 67, 69, 70, 71 from Hamrick Software; page 174 from ColorMunki; pages 188, 189, 191 from Shutterfly, Reproduced by permission of Shutterfly, Inc., Copyright © 2011 Shutterfly, Inc. All rights reserved; page 195 from Moo.com; pages 201, 202, 203, 205, 207, 208, 210, 211, 213 from Tumblr Inc.; page 220 from Panoramio.

In some instances we have been unable to trace the owners of copyright material, and we would appreciate any information that would enable us to do so.

in Simple steps

Contents at a glance

8 Share images via the Internet

Top 10 digital photo problems solved

Contents

2 Shoot, transfer and scan

3 Organise and browse: find your photos fast

4 Basic editing and image tuning

5 Prepare images for sharing

Top 10 digital photo problems solved

Top 10 digital photo-sharing tips

Tip 1: Choosing software? Some suggestions

Your choice of software will depend on how you shoot, what you want to do with your images, what platform you're working on and your budget.

Non-destructive editors

If you plan to only shoot JPEG images and share exclusively via the Web, Google Picasa is a good choice. It helps you organise and find files on your computer, does basic non-destructive editing and provides easy uploading to Picasa Web Albums from your computer. It is available as a free download for both Windows and the Mac.

Adobe Photoshop Lightroom is an excellent price/performance choice with room to grow. It allows you to edit raw, JPEG, TIFF, even Photoshop files. Its database allows you to manage archived images on media that can be disconnected from your computer, and its search and organisation tools are extremely advanced. Its non-destructive editing capabilities are equivalent to Adobe Camera Raw, which ships with Photoshop, but with an improved interface and workflow. Lightroom integrates smoothly with Photoshop and Elements, adding easy access to pixel-editing capabilities while functioning as an upgrade to Bridge and Organizer. Available for both Windows and the Mac.

Apple's Aperture is a significant upgrade to iPhoto, both of which are available exclusively on the Mac. Many capabilities are similar to those found in Lightroom, though it does not provide the same smooth integration with pixel editing tools like Photohsop or Elements. It can organise and non-destructively edit both raw and JPEG images. Aperture exports easily to Flickr and Facebook, and available export plug-ins work with a number of other sites. Not surprisingly, Aperture's integration with Mac OS X Media Browser is strong. Aperture also has built-in tools for creating and printing photo books.

Pixel-based editors

Corel's PaintShop Photo is a bargain-priced photo-editing application exclusively for Windows. It offers both image management and pixel-based photo editing. Its feature set positions it somewhere between Adobe's Photoshop Elements and Photoshop.

Adobe Photoshop Elements is a pixel-based editor available for both Windows and the Mac that is priced similarly to PaintShop and is aimed primarily at the consumer market. It has an image management tool similar to Adobe Bridge. Its editing tools have some of the capabilities of both PaintShop and Photoshop, but they are simplified versions with built-in assistance and ease of use in mind. Elements cannot edit in 16-bit or work with 32-bit HDR images. Some features can be unlocked to extend its capabilities, but there are a number of features that are only available in Photoshop.

Adobe Photoshop is the leading pixel-editing application. It offers professional-grade capabilities that exceed those of most other software, but they come with a premium price and a steeper learning curve. If you are interested in advanced compositing features, Photoshop can take you further than anything else on the market. Photoshop is bundled with Bridge for browsing and organising images and Camera Raw for non-destructive editing of raw, JPEG and TIFF files. Lightroom has integration features that allow it to integrate cleanly with Photoshop, improving the functions of Adobe Bridge and Camera Raw, which come bundled with Photoshop.

Book-printing software and services

In addition to the photo book features built into Aperture and iPhoto, several vendors have websites with tools for creating custom photo books.

Blurb offers three different methods for producing custom-printed books. Bookify offers a simple online workflow that requires no downloading. BookSmart® is their intermediate-level tool with more flexibility and options. You can download BookSmart for the Mac or a PC. Their advanced PDF to Book workflow is a third option that allows full design control. Blurb provides templates for Adobe InDesign and ICC profiles for accurate colour management. All of their downloadable tools are available free of charge.

Photobook offers book printing with handmade construction and premium materials, such as leather binding and embossing. You lay out your book using their Photobook Designer software, available as a free download for both Windows and the Mac.

Tip 2: Make your photos ready for sharing

Whenever you're sharing photos via e-mail or the Web, three key issues are the pixel dimensions, file size and colour space of your images. It's best to convert your photos to sRGB and make them a size that fits well onscreen and loads quickly.

When you're editing your images, there are advantages to editing in Adobe RGB or even ProPhoto RGB, but both of those colour spaces are problematic when images are posted on the Web. This is because most displays are capable of showing only the sRGB colour gamut at best and many browsers do not support colour management – without it, the colours will be wrong. Many image-editing applications have an option to convert your image to sRGB when you export to JPEG or save for the Web.

Size your images with the destination in mind. Photos from an iPhone measure 2592 × 1932 pixels; that's actually larger than a 27-inch iMac screen, which has a resolution of 2560 × 1440. It's nearly triple the size of some netbooks, which may have screen resolutions as small as 1024 × 600 pixels. Most screens fall somewhere in between, with a substantial proportion of them measuring 1024 × 768.

Thus, images that are more than about 800 pixels on the long dimension are likely to have issues fitting on most people's screens. When your image is too big, some software will scale it to fit the screen, but often the person receiving it will have to scroll to see the parts that don't fit on the screen. Big files also take more time to download, since they contain more bytes of data. That's one reason the iPhone has options to shrink your photos to as little as a fiftieth of the original size when you send them as e-mail attachments.

Even though you can upload PNG and other file types to some websites, JPEG files are the most portable, because they are compressed and the format is practically universal. When you save JPEG files, you usually have the option to select a quality level. High-quality images are bigger, but do not display the artefacts that low-quality JPEG images are known for. While you might be tempted to save your JPEG files at the

maximum quality setting, dropping the quality a little can dramatically reduce the size without significantly degrading its appearance. If you go from a quality setting of 100 to 90 (from 12 to 9 in other dialogue boxes), the difference in the file's appearance will be hard to detect, but it can reduce the size of your file by as much as two thirds.

Lightroom

Photoshop

ALERT: Photoshop's Convert to Profile command can translate the colours in your image to any colour profile installed on your computer, but be careful with this feature. Do not save and replace your original after you have converted the colours of your file – converting the colours can degrade your image and flatten any layers.

Tip 3: Create a presence on the Web

When it comes to sharing images, one of the easiest ways to do so is to post them on the Web. If you're just interested in uploading them somewhere so that you can send links to friends and family, you can simply build a personal Web gallery with your Windows Live or Mobile Me account and you're pretty much done. If you're interested in making your work more broadly available, however, that approach won't work so well.

Just because you build a website doesn't mean that anyone else will find it. To do that, you'll want your images to be indexed by search engines and you'll want to network with other photographers. That's one argument for having a presence on membership sites like Flickr, Photoshelter, Facebook, LinkedIn, deviantART and so on. You can create various types of image galleries, connect with new friends, join groups and promote what you do.

An entirely different approach to connecting with a following is blogging. If you post photos, text, links and commentary on a regular basis, chances are good that your blog will show up on search engines like Google. Since search engines are much smarter about text than they are about images, it helps to write about timely topics and tag your photos with relevant keywords and alt tags.

If you make it possible for people to contact you through comment forms (you don't have to publish your e-mail address and become subject to spam), then you can establish two-way communications with your readers. Tumblr offers a simple and elegant way to create blogs and it has options for allowing visitors to interact with you. They can ask and respond to questions. You can even set up posts that allow them to respond with a photo of their own. If they like your post enough, they can repeat it on their blog with attribution back to you. That increases the likelihood that people will see your posts and find their way to your blog.

Many people create profiles on a number of sites and then integrate the sites by linking them. You can have a personal portfolio or blog site (such as YourName.com) that serves as a hub containing links to and from all the other accounts you establish. The mix of connections is up to you and your creativity.

Post a Question

What's all this sharing stuff about?

Ask as photosimplesteps log out **Ask**

Tip 4: Become app-savvy

Camera-equipped smartphones have become the new instant photography and, for some, their only camera is in their phone. Camera-related apps have sprung up to provide creative options and performance enhancements. There are apps to simulate the look of a broad range of cameras, lenses and film types, from the Holga (a plastic camera from China) to Polaroid (including its desaturated colour palette and distinctive border). Creative apps are available to allow you to alter the look of images and even combine them to simulate multiple exposures and layer effects similar to some Photoshop ones.

The key ways to connect to Web content seem to be shifting rapidly from using browsers on computers to apps on portable devices. Social networks, blogging and sharing platforms, such as Facebook, LinkedIn, Tumblr and Flickr, have all responded and developed their own apps. There are even apps that allow you to work with multiple sites. The result is that it's easier than ever to have access to your work whenever and wherever you want to show it or update it. Most apps are pretty minimal, which means you won't be spending hours with a user manual trying to figure out how to make them work.

You can literally take a photo with your smartphone and post it to a blog such as Tumblr within seconds. If you're a citizen journalist, you can use the iPhone's ability to record and edit high-definition video, and apps can provide nearly real-time video and still-image updates to your sites. With a little visibility and some luck, you might find your work going viral – all from an easy-to-use device that fits in the palm of your hand. New apps are coming out all the time.

HOT TIP: The iPhone's camera app snaps a picture when you remove your finger from the camera button. To reduce camera shake, hold your finger on the button until your hand feels steady, then remove your finger from the button to grab your shot.

Tip 5: Set your camera to name and number images for you

In the first chapter of this book, we'll take a look at ways to manage the potentially thousands of photos you may take with your digital camera. Effectively managing and finding those photos starts with how you name them; you want all of your filenames to be unique, and you can name your files so that they provide useful information beyond the order in which they were taken.

Many camera models have an option to override the default names that your camera assigns to its files so that the names are more useful. For example, the Nikon D200 names its files by default with a generic three-character prefix (DSC) followed by a sequence number, such as DSC_1234 or _DSC1234. If you have more than one camera, you could change the prefix of the files from this camera to something like D2A. The 'D2' could indicate images coming from the D200, and we'll look at the A designation shortly. On the D200, the feature is controlled through the File Naming option in the Shooting Menu. Check your camera's manual for a topic like 'File Naming' for details.

The second part of the filename is a sequential number that the camera assigns to each photo to make sure the filenames are unique as it saves them on to the memory card. In some cameras, you have to activate an option to keep counting up when you change media cards. The D200 comes from the factory with the numbering set to start over at 0001 whenever you insert a new media card. To have the camera keep counting up until you hit 9999, you need to turn on the feature that controls file numbering. Look in your camera's manual for something like 'file numbering', 'file sequence' or 'sequence numbers' to find out how to adjust this setting.

To change the sequential number setting on the D200, activate the Custom Setting Menu, then select (d) Shooting/Display and, finally, select (d6) File No. Sequence. Select the ON option and then select OK to set it.

Returning to the D2A example above, the 'A' would indicate that the file numbering sequence is in its first cycle from 0001 to 9999. You could change the prefix to D2B when the counter starts over. That strategy guarantees you'll never have two files with the same name from that camera.

HOT TIP: Nikon puts the underscore character either at the beginning or in the middle of the filename to indicate whether you set your camera's colour space to sRGB or Adobe RGB respectively.

_DSC3696.NEF _D2B3696.NEF

Tip 6: Don't delete images on your camera

Deleting files on your camera is not a good idea because it has the potential to corrupt other photos on your card. It's a rare occurrence, but it does happen. It's also not a good idea to automatically delete your files when you download them from your camera.

Even when you're shooting raw, you can typically fit several hundred shots on an 8GB card, so it's a lot less likely that you'll run out of space on your card while shooting. That means the temptation to free up space by deleting images you don't like will be less and that's good.

A recommendation for dealing with your camera's memory cards is the following.

1 Copy the entire contents of your camera's card to your computer, but don't clear the card yet.

2 Review the files to ensure that they copied correctly.

3 Back up the files immediately after you have copied them to your computer.

4 Reformat the camera's memory card to clear the contents once you have confirmed that the copy went smoothly.

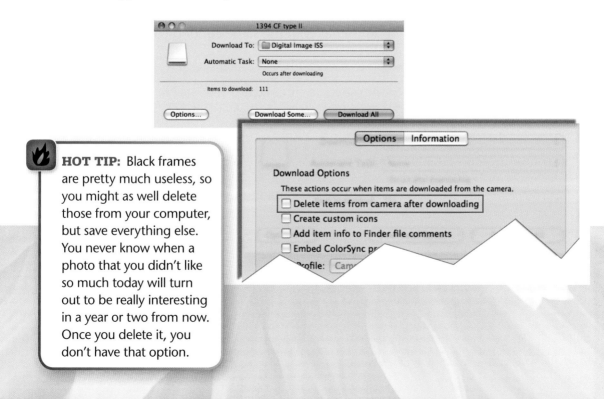

HOT TIP: Black frames are pretty much useless, so you might as well delete those from your computer, but save everything else. You never know when a photo that you didn't like so much today will turn out to be really interesting in a year or two from now. Once you delete it, you don't have that option.

Tip 7: Get better white balance

When you select the wrong white balance, you introduce colour casts into your photos that can be distracting or worse. If you shoot in JPEG, it's very important to get the white balance right, because you have limited ability to recover when you edit the photos. If you shoot raw, you can select any white balance setting you like beforehand, but shooting lots of photos with the wrong white balance adds editing time you could have avoided. Here are several tactics for getting better white balance in your shots.

- Avoid using Auto White Balance. The feature *seems* convenient, but it pretty much guarantees that the colour will be different in every single shot you take.

- Optional: choose a standard white balance setting – that is, Incandescent (tungsten), Fluorescent, Direct Sunlight or Shade. Match the white balance setting to the type of light you have for a neutral rendition.

- Optional: pick the 'wrong' colour temperature for creative effects. Use the Direct Sunlight or Shade setting with incandescent lights to create a warm golden effect. Use the Incandescent setting outside to render everything a cool blue.

- Optional: use a neutral grey card with your camera's white balance preset option to dial in a more accurate white balance setting in-camera.

- Optional: shoot in raw and shoot a test frame with a neutral grey card whenever the light changes. In your raw-processing software, use the white balance sampler tool to read the grey card in your test frame and measure the white balance. Apply the sampled white balance to other frames with the same lighting condition.

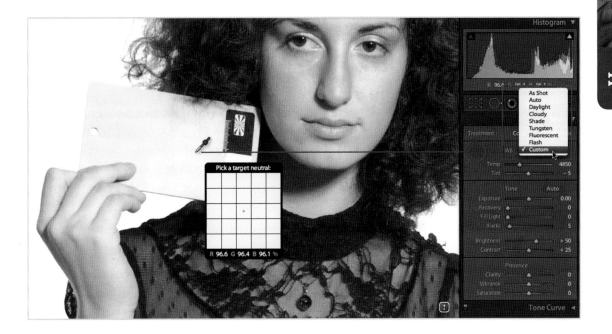

Tip 8: Share your hard drive with both Macs and PCs

Hard drives usually come preformatted for the computer you want to connect to, so that they're ready to use out of the box; this saves you the time necessary to format a large drive. Macs and Windows on PCs have incompatible filing systems – HFS on the Mac and NTFS in Windows. If you have a portable hard drive that you want to share between both platforms, you have two options: either reformat your hard drive with an older file system that both PCs with Windows and Macs can read and write to or install a driver that makes your Mac or Windows machine able to read and write files on the other platform's file system.

Windows NTFS is read-only for Macs, and Windows machines do not recognise drives formatted for Mac OS at all. Only the MSDOS (FAT) file system allows both Macs and Windows machines to read and write files. This option is available at no charge, but there are varying limitations to the FAT (short for File Allocation Table) file system, depending on the version you use. Another option is to purchase and install a Mac or Windows driver to enable your machine to read and write files on the normally incompatible drive. The advantage of this approach is that you get to use the most up-to-date file systems.

- Reformatting erases your drive. So, if you plan to reformat your drive, back up any files on the drive so that you can restore them after you have reformatted.
- To format with a Mac, use Apple's Disk Utility to erase and reformat the drive. The application is found in the Utilities folder inside the Applications folder.
- To format with a Windows machine, use the storage management options under the Start menu to reformat the drive.
- Paragon Software offers HFS for Windows and NTFS for the Mac. Visit www.paragon-software.com for more information.

ALERT: Some forms of the DOS FAT file system cannot handle files larger than 4GB. If you're working with video, this can be a problem. On Mac OS X 10.2, MSDOS-formatted disks larger than 128GB would not show up in Finder. This has been resolved in newer versions of Mac OS X.

SAMSUNG MP0402H Media

Verify | Info | Burn | Mount | Eject | Enable Journaling | New Image | Convert | Resize Image | Log

First Aid | Erase | Partition | RAID | Restore

232.9 GB FUJITSU MHY225.
 Macintosh HD
465.7 GB LaCie
 Lux Numeri
7.6 GB 1394
 NIKON D200
37.3 GB SAMSUNG MP0402
 LILRED
MATSHITA DVD-R UJ-867

To erase all data on a disk or volume:
1 Select the disk or volume in the list on the left.
2 Specify a format and name.
3 If you want to prevent the recovery of the disk's erased data, click Security Options.
4 Click Erase.

To prevent the recovery of previously deleted files without erasing the volume, select a
volume in the list on the left, an

Mac OS Extended (Journaled)
Mac OS Extended
Mac OS Extended (Case-sensitive, Journaled)
Mac OS Extended (Case-sensitive)
✓ MS–DOS (FAT)

Volume Format:
Name: SHARE HD

Erase Free Space... Security Options... Erase...

Disk Description : SAMSUNG MP0402H Media **Total Capacity** : 37.3 GB (40,060,403,712 Bytes)
Connection Bus : USB **Write Status** : Read/Write
Connection Type : External **S.M.A.R.T. Status** : Not Supported
USB Serial Number : 10000E00082C3A0D **Partition Map Scheme** : Apple Partition Map

Tip 9: Hard drives fail

Have you ever noticed that nobody acts as if a light bulb will burn forever, yet we use hard drives as if they'll never crash? The reality is they're mechanical devices that contain tiny mirror-polished discs spinning at something like 120 kilometres per hour. The read-write head hovers less than a hair's breadth above the disc's surface – so close that a speck of dust would have the effect of a wrecking ball. Given the incredibly tight tolerances needed to make them function at all, it's actually a wonder that they last as long as they do.

When drives *do* wear out, we often don't see whatever warning signs they might exhibit (gradual slowing of data transfer or slower startup, for example) as warnings. Then, suddenly, the drive just won't show up on your computer. If you're lucky, it's an electronic problem like the power supply. Those can be replaced without any loss of data. If not, you may find yourself being consoled by friends over some valuable images or other files that you have lost. It's easy enough to prevent such calamities by having a regular backup routine in place.

Another precaution you can take is to save your work-in-process and archive files on a RAID level 1 (mirroring) drive array such as the LaCie 2big and 4big drives. These units look like one drive to your computer, but they're actually twin drive units that create an instant backup for anything you save. When you save your file, it's written to two separate drives. If one fails, you'll get an alert and you can swap out the failed drive without losing any data. Once you replace the drive, the RAID system replicates the data on the new mirror drive. A more advanced version of the RAID system is the Drobo from Data Robotics. (Visit www.lacie.com and www.drobo.com for more information about these drives.)

HOT TIP: Some of your most valuable data can be your e-mail address book and other data that are stored on your computer's built-in startup drive. Chances are you'll keep your photos on an external drive, so be sure to have a routine for backing up and restoring your startup drive, too.

Tip 10: Find out about copyright and creative commons

Sharing photos online can be fun and satisfying, but it has a dark side that it pays to be aware of. As soon as you post your photos on the Web, it becomes possible for people to grab them and use them for their own purposes without your permission. For some, that's a major issue, particularly if they make a living from licensing their images. Intellectual property laws are complicated and vary by country. I certainly can't provide legal advice here, so it's important to seek proper legal advice in your country to learn how copyright works and determine your own copyright management strategy (you can find out more about copyright at www.eucopyright.com).

As the copyright holder of an image, you can grant limited rights to others while retaining the rest. Professional photographers and corporations typically use this 'all rights reserved' approach. However, that approach to licensing can discourage sharing and building on the work of others. Creative commons licences are based on a 'some rights reserved' approach and are designed to encourage free and legal sharing (you can find out more about creative commons at http://CreativeCommons.org).

A number of services are emerging to assist you in finding pirated copies and even modified versions of your images on the Web. TinEye.com has an image search engine that can find versions of an image based solely on the image content. There are services that can detect when someone is using your image and pursue them legally on your behalf and ones that can help you register your photos.

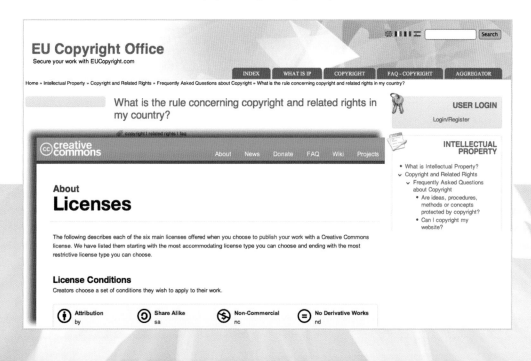

1 Think workflow: plan your process, choose your tools

Introduction

As the title suggests, this book is about being able to share digital photographs from a number of perspectives. The challenge of writing this has been to distil a very broad set of topics down to something that will be useful to a range of people with very different needs. We'll begin by getting files on to your computer, look at various options for shooting, scanning and editing images, then, finally, look at just a few prime examples of ways that you can share photos with your friends and family or even make new friends with your photos.

If you're new to digital photography, you may well have a camera full of photos that you have never transferred to your computer. You carry the camera around with you, sharing photos with friends by showing them the little screen on the back. Another possibility is that you've shot a lot of film and you'd love to share digital versions of the prints or slides that you've amassed over the years. In either case, your first challenge may well be getting your photos on to your computer.

You may have transferred images to your computer and worked with them, but you may not be completely happy with the software that you're using. We'll look at a range of software options and discuss the suitability of each for different styles of sharing images.

Perhaps you've transferred photos onto your computer, but you're having trouble finding them when you need them or you'd like to learn more about editing photos. Along the way, there are all those potentially confounding issues of setting preferences, getting the colour right, preparing images for the Web, attaching them to e-mails or printing them.

With this book, you'll get grounding all those things, so that phrases like 'colour space' won't be foreign terms any more.

If your camera is a smartphone, you may want to use it to share photos directly or edit them on your computer and return them to the phone to use as a digital picture frame. Beyond that, there is a wide array of ways to share digital photos, from blogs to printed goods like mugs. The complete range of possibilities is actually too broad to cover in this small volume, but this book is designed to take you to the next level. We'll look at the tools and techniques that will help you to quickly find the photos you want, enhance them and make them available to your personal circle.

Digital photography tasks

The list below describes, in broad terms, what can be done with digital photos, roughly in the order that they are done. It is the most general form of what could be termed a workflow, although colour management is actually not a task but an umbrella process that affects the tasks of previewing, enhancement, formatting, printing and sharing electronic images. There are several points in the workflow where it makes sense to make backups, depending on how secure you want your images to be. You may not perform every task listed, either – that will be determined by how you use your images.

The remainder of this book will expand on these tasks, processes and tools.

- Transfer or scan to your hard drive.
- Organise, archive, back up.
- Browse/retrieve.
- Preview.
- Process raw files.
- Non-destructive enhancements.
- Manage colour.
- Pixel-based editing.
- Format.
- Print.
- Share.

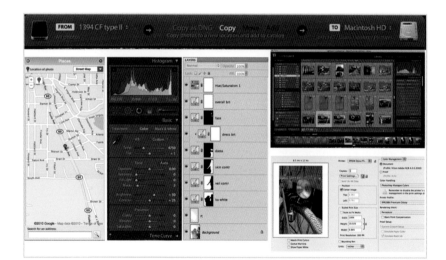

WHAT DOES THIS MEAN?

Workflow is just a glorified word for your process or the order in which you do things to your images. If you have worked with digital photos already, then you have a workflow, or maybe several of them, but they may not be streamlined. The idea of creating good workflows is to produce more consistent results with less effort. The steps you take and the tools you use are all about achieving your end result. Someone who intends to make large prints from scans of old family photos is going to have a very different workflow from someone who wants to take photos as-they-are from their camera and put them into a Flickr collection.

The tools you choose will constrain what you can do with your workflow, and your finances and operating system may constrain which tools you choose. Another significant distinction in your workflow will be whether you plan to process raw files or only work with JPEG or TIFF files. Working with raw files adds the step of processing an image, but many of the available tools make that step part of the basic adjustments you might make to any image. If you're working with JPEG or TIFF files, some tools allow you to work with them in the same manner that you work with raw files, while others create a separate workflow. Generating books or PDF files containing multiple images and layout elements are examples of extended workflows.

Batch-orientated workflows are great for situations like photographing events where the individual photos don't have to be masterpieces. Once you have selected which photos you would like to share, you can make certain adjustments to them en masse, then click a button to build a Web gallery or generate a set of JPEGs of a specific size.

While there are still some simple tools that only edit images, most at least offer some form of file browsing or cataloguing so that you can more easily select the images you want to work on. Working inside a single unified environment has its advantages, but in some cases you may prefer to use separate, specialised applications for tasks such as cataloguing, raw processing or image editing.

Dealing with lots of photos

With a digital camera, it's very easy to shoot hundreds of photos in a single day. Aside from filling up memory cards and disk space, simply keeping track of the sheer volume creates a challenge. There are a few keys to managing your photos effectively. By naming your files according to a consistent convention, putting your images into folders in a structured way and adding keywords and other metadata, you can retrieve that particular photo of Cleopatra's Needle among a haystack of photos very quickly and efficiently. Newer software can even help you match files by the faces in them or the location in which they were taken. Automated tools, such as presets, templates and smart filters, can help you apply keywords and other metadata easily or gather images with very little effort.

- Give files unique names.
- Store files systematically.
- Add metadata to the files to make them easier to find.
- Use automated tools to help manage images.

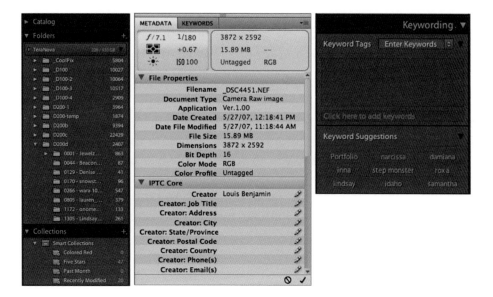

WHAT DOES THIS MEAN?

You will hear the term **metadata** a lot. It simply means data that describe the content of your images. Some of the metadata that your camera automatically records include the date and time an image was shot, shutter speed, aperture, white balance and the camera make and model. You can add metadata of your own, including copyright and caption information, keywords and ratings.

Considering JPEG v. raw shooting

When in doubt, it's generally a good idea to shoot raw files, because they are more forgiving. With JPEG, it's critical to get the exposure and white balance right and to use the highest-quality setting when you shoot. Roughly speaking, you're trading off between the simplicity, small file size and speed of JPEG, and the higher image quality and processing flexibility of raw. Given the trade-offs, there are times when it may make sense to shoot JPEG images, even if you have a camera that can shoot raw. While some people act as if JPEG images are evil, they're not; the format just makes certain compromises that are not made when shooting raw files.

Your camera contains a small onboard computer. When you shoot a JPEG, that computer reads the data from the camera's sensor and renders an image. In the rendering process, your camera's white balance and tonal settings are applied to the sensor data, then the image is converted to 8 bits per channel, compressed and saved. JPEG compression is known as 'lossy' because it discards a certain amount of image data from the moment of capture and it cannot be recovered.

A raw file is essentially an envelope, not an image. It is analogous to film that has been exposed but not developed. When you shoot a raw file, the camera's computer stores copies of the sensor data and the camera settings inside the file along with a thumbnail image and a JPEG preview.

You process raw files on your computer, using either the camera manufacturer's software or third-party products, such as Lightroom or Camera Raw. In the raw processing software, you have options that allow you to correct the white balance setting, recover highlights, work with tones and perform other adjustments to an extent that is not available in a JPEG image. You can also preserve the full 16-bit data captured by the sensor and render your files in lossless formats, such as Photoshop and TIFF.

ALERT: Every camera model has a unique raw file structure so, when new cameras are released, there is a delay before you can see previews in Windows or Mac OS or edit those raw files with third-party software. That is because the software has to be updated to read the new raw file structure.

Table 1.1 JPEG v. raw shooting

	JPEG	Raw
Rendering	in camera	on computer
10 megapixel file size	5MB (max)	15–60MB
Compression	10+ ×	0–4 ×
Data loss?	Yes	No
Exposure latitude?	No	Yes
Highlight recovery?	No	Yes
Bit depth	8	16

HOT TIP: Raw files are typically three to six times larger than the corresponding JPEG files. You can estimate the uncompressed file size (in megabytes) of your camera's raw images by multiplying the megapixels by six. Some raw files may be somewhat smaller because they use a bit of lossless compression. Shooting raw files can slow some cameras dramatically and fill your media card much faster than when shooting JPEG.

Scanned images are digital photos, too

You can think of a scanner as a specialised camera that 'rephotographs' negatives, slides or prints. A high-quality scanner can capture a lot of information, producing a file with even more data (and a bigger file size) than you get from a 10- or 12-megapixel camera. Good scans can be used to make prints much larger than the 13 × 19-inch size that the popular Epson R2880 printer is capable of. Just as with photos from your camera, naming your scans effectively and adding metadata will help you retrieve them with ease.

SEE ALSO: See Chapter 2 for details on scanning for best results.

Choosing between cataloguing and browsing

Once you have transferred files on to your computer, two tasks you'll frequently undertake will be reviewing your work and selecting files to edit. Both Windows Explorer and the Mac's Finder have a number of built-in tools for browsing and previewing files, even presenting slide shows, but they are fairly limited.

The image-organising tools in applications like Photoshop Elements, Windows Live Photo Gallery, Lightroom and Adobe Bridge improve on the browsing and slide show abilities of the operating system tools and add options for tagging, prioritising and organising images. They offer better integration with image editors, which streamlines your workflow.

When it comes to browsing and previewing files, there are two distinct approaches that can be taken. The operating system of your computer and tools like Adobe Bridge are browsers. They primarily use the structure of the folders on your computer as the framework for presenting your files. You navigate among folders and view sets of thumbnails one folder at a time. Browsers can only show you the contents of volumes (hard drives or CDs, for example) that are mounted on your computer. As soon as you eject a drive, those thumbnails and previews disappear from the browser.

Cataloguing applications like Lightroom's Library module and Microsoft Expression Media can scan a folder or drive and compile a database that contains the locations of your files, along with thumbnail and preview versions of your images. Once you scan a drive, you can eject it and continue to browse the catalogue database and even add tags, ratings and other metadata. You can keep the drive containing the original images disconnected and switched off until you need to edit any of them.

The catalogue will indicate whenever files are missing or offline. If you move folders that you have catalogued to a new location, the catalogue will not know where to find its original files. In that case, the catalogue software gives you a way of pointing to the new location without having to re-import the images.

Considering pixel v. parametric editing

Two different approaches to editing images have evolved in the 20 or so years since Photoshop was first introduced, ushering in the technology of digital editing. Pixel editing (also known as 'pixel pushing') came first and it works by altering the pixels in an image, which destroys the original image data. Parametric editing works non-destructively and never alters the original image directly. Instead, the parametric editor records what is essentially a recipe for producing the result that you see in its preview screen. The preview updates each time you change a setting and the recipe is stored as metadata alongside the original image. The editor uses the recipe to cook up a revised copy of the image whenever you save a JPEG file or export the image to a pixel editor for further refinement.

In Photoshop, the Brush tool, the Healing Brush, the Eraser, the tools in the Adjustments menu (Image, Adjustment, . . .), as well as the Filters menu, all work by altering the pixels in a layer. As Photoshop has evolved, techniques like editing a copy of a layer and using Smart Objects have been developed to allow you to use Photoshop's destructive editing tools in a pseudo-non-destructive way. Photoshop now contains some non-destructive tools, such as adjustment layers and blending modes, but it's left to you to maintain non-destructive practices and ensure that you're not irreversibly changing your only copy of a file.

Lightroom and Camera Raw are parametric editors that can edit raw, JPEG and TIFF files. Lightroom is a standalone application that can also edit Photoshop PSD files, while Camera Raw is a plug-in module that you access from within Photoshop or its companion file browser, Adobe Bridge.

Parametric editors cannot edit layered files and they do not operate at the pixel level, so they are great for tuning images, but you will still need a pixel editor for certain types of retouching, as well as layer-based image editing. On the other hand, you can save your edit parameters as snapshots or presets in Camera Raw and Lightroom. This allows you to easily and efficiently process the same image many different ways or apply the same edits to multiple images at once.

Considering sidecar metadata v. DNG

As mentioned earlier, when you edit a raw file, the parametric adjustments are saved non-destructively alongside your original image. By default, the adjustment metadata are stored in a companion file called a sidecar.

The editing software creates and names the sidecar file to match the raw file it relates to. The first part of the file is the same as the originating raw file, but the extension is .xmp. For example, if you edit a raw file called LB_1234.NEF, its sidecar file will be LB_1234.xmp.

Whenever you open a raw file, the editing software looks for a matching sidecar file. If it finds one, it will use the enclosed xmp adjustments to build the preview. If it does not find a matching file, it treats the file as if it had never been adjusted. This means that if you move or copy a raw file to another drive, it's important to move or copy its matching xmp file along with it.

Aside from the problem of accidentally separating raw files from their sidecars, camera manufacturers do not document their raw file formats and some even encrypt parts of the files to make it harder for third parties to accurately render them. There have already been a few cases of cameras that have been discontinued and, no, there is no current raw processing software that can read their raw file formats.

To address this problem, Adobe has developed a documented standard called the DNG format and they are campaigning to have it adopted as an industry-wide format. Documenting the format means anyone can write software that reads it, making the format more archival in the long run than the manufacturers' proprietary formats. DNG files contain the xmp data along with the other raw file components in a single document. You can optionally embed a copy of the original raw file so that you can extract it at any time, if you wish.

Using the DNG format adds some steps to your workflow and there are some performance bottlenecks. It's best to do your initial adjustments in your raw editor before converting to DNG.

DSC_1341.NEF
+
DSC_1341.xmp
= DSC_1341.dng

HOT TIP: Nikon raw files have the .NEF extension. If you have a Canon camera, the extension may be .CRW or .CR2. Other raw format extensions include .SRF, .SR2, .ARW, .PEF, and .RAF.

A look at Google Picasa 3

If you only shoot JPEG files and primarily share via the Web and e-mail, Picasa has a solid set of features that may be sufficient for your entire workflow. You can even order prints via Picasa from online services that have partnered with Google. Picasa is available as a free download for both Windows and the Mac. The image-editing tools in Picasa are non-destructive. While Picasa can display thumbnails for raw images, it cannot edit them and may not display the colours accurately.

Picasa automatically catalogues every image on your computer's hard drive by default. It also watches those folders to catalogue any new files you add to them. If you prefer to only catalogue certain folders on your computer, you use its folder manager to turn off the automatic features.

- Import images from camera.
- Integrated file browser.
- Parametric (non-destructive) image editing.
- Basic fixes and retouching.
- Colour and tone adjustments.
- Effects (such as film grain, sepia and soft focus).
- Tag by keywords, face recognition and geo-tags.
- Upload to Picasa Web Albums and Blogger.
- Create slide show videos with music.
- Collage maker.

? DID YOU KNOW?
You can find out more and download Picasa at:
http://picasa.google.com

► SEE ALSO: Geo-tagging photos allows you to link them to points on a map. See Chapters 3 and 8 for more details.

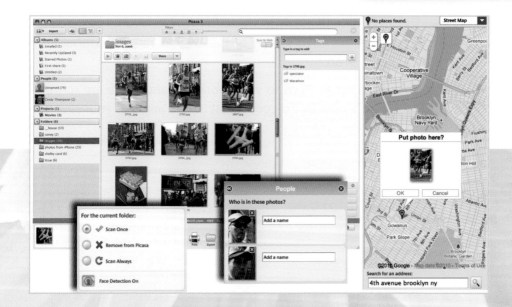

A look at Photoshop Elements 9

Known as Elements for short, this application is considered a more 'consumer-friendly' version of Photoshop, although it seems to have borrowed more of its interface design from Lightroom than Photoshop. It is aimed at amateur photographers and costs a fraction of the price of Photoshop. Considered one of the easiest applications to learn, it is a pixel-based editor that supports raw, TIFF and JPEG files and contains simplified versions of many of the tools found in Photoshop CS5. It also has some automated options and a Guided Edit mode not found in Photoshop. Its tools for retouching, combining and making image collages are more advanced than those found in parametric editors such as Picasa and Lightroom. You browse and organise images with Photoshop Elements Organizer. It is a separate application that comes bundled with Elements and is similar to Adobe Bridge, which comes bundled with Photoshop.

The Spot Healing Brush in Photoshop appeared in Elements before it was added to Photoshop and now this version of Elements borrows Layer Masks and Content-Aware Fill from its big brother.

- Import images from your camera.
- Browse files with the separate Organizer application.
- Browse images by date.
- Guided Edit mode.
- Content-Aware Fill and Healing Brush to remove unwanted elements.
- Content-aware panorama stitching automatically fills gaps.
- Combine layers with layer masks.
- Photo book layout.
- Simple upload to Facebook, Flickr and so on.

? DID YOU KNOW?
You can find out more and download a trial version of Photoshop Elements at www.adobe.com/products/photoshopel

Home / Downloads /

Download a free trial of Adobe Photoshop Elements 9

pse

Adobe Photoshop Elements 9

| English | Mac | 2.01 GB |
System requirements | Trial FAQ

Thank you for your interest in evaluating Adobe® Photoshop® Elements 9 software. The trial version is fully functional and offers every feature of the product for you to test-drive*.

Available language versions
The Photoshop Elements 9 trial is currently available in English, French, German, and Japanese for Microsoft® Windows® and Mac OS. Additional language versions for Windows are also available.

This trial download is distributed using the Akamai Download Manager. By downloading this product trial I accept the **Akamai End User License Agreement**.

A look at Lightroom

Officially named Adobe Photoshop Lightroom, it is often described as a 'workflow tool' that integrates catalogue management, parametric editing and output in a single application. Lightroom can edit JPEG, flattened TIFF and Photoshop files that have been saved with the Maximize Compatibility setting.

Depending on what you want to do with your images, Lightroom may provide all of the image-editing capability that you need. You can master the tools in the Lightroom Develop module in a fraction of the time it takes to learn the tools in Photoshop, though there are some things that you can only do with tools like Photoshop. Lightroom can be integrated with Photoshop or Elements to take advantage of pixel-based tools, layers and masking.

One advantage of the catalogue database in Lightroom is you can search and preview images stored on drives or disks that have been disconnected from your computer.

- Import images from your camera.
- Integrated catalogue management.
- Parametric (non-destructive) image editing.
- Presets in the Develop module simplify processing and allow you to apply saved looks.
- Lens correction.
- Watermarking tool (stamp photos with your logo).
- Create slide show videos with music.
- Simple upload to Facebook, Flickr and so on.
- Advanced printing features.
- Integrates with Photoshop and Elements.

HOT TIP: You can preview images from drives that are not connected to your computer, but you will still need to attach the drive to adjust the files in Lightroom.

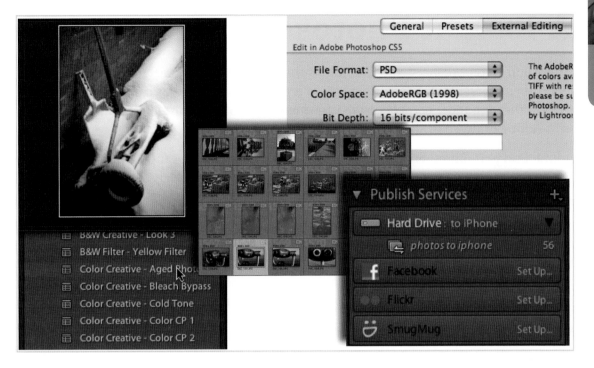

A look at Photoshop

Photoshop is the original pixel-pusher and the established standard for image editing. Its brushes, layers, masks and effects allow a tremendous range of creative freedom, though they are more complex to master than some other tools. Photoshop CS5 comes with Adobe Bridge and the Camera Raw plug-in.

Adobe Bridge is a browsing tool that allows you to manage files, apply metadata and open files in Camera Raw or Photoshop as needed. Bridge also has tools for creating slide shows, Web content and PDF documents.

With the advent of Adobe Camera Raw, parametric editing has emerged as a non-destructive way of doing some of the tasks that used to be done in Photoshop. It can function as a 'developer' for raw files as well as a non-destructive pre-editor for JPEG and flattened TIFF files. You can adjust images and do some retouching in Camera Raw, then pass the image on to Photoshop for further refinement, printing and so on.

- Transfer images from your camera, file management and browsing via Bridge.
- Instant slide shows and full-screen previews via Bridge.
- Pixel-level editing.
- Advanced compositing.
- Parametric editing via Camera Raw.
- Selections, layers and masks.
- Mixer Brush and Bristle Tips simulate natural media.
- Type tool for adding text.
- Colour management and colour space conversion.
- Smart objects.
- Channel-based operations.
- Automation with Actions.
- Upload to Flickr and Facebook via the Bridge Export module.
- Create Web galleries and PDF documents via the Bridge Output module.

HOT TIP: Instead of being a standalone application, the Camera Raw plug-in is 'hosted' within either Photoshop or Bridge. That means you don't open Camera Raw directly, but invoke it as a dialogue from within either application. Whenever you adjust a raw file, the Camera Raw dialogue box automatically opens.

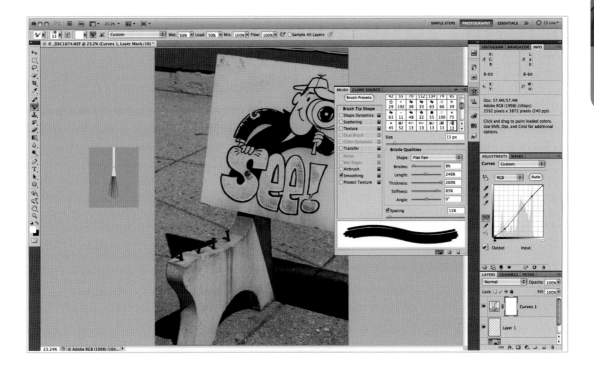

Adding functionality with plug-ins

An entire industry has sprung up around creating plug-in software that adds features to Photoshop and Lightroom. By adding raw processing to Photoshop as a plug-in, Adobe can issue simpler updates when cameras come out with new raw formats.

In many cases, these products offer alternatives to functionality that is already available in some form within Photoshop, but they do so with a different interface or workflow. Many of the available plug-ins also work with software from other companies, such as Corel's PaintShop Pro. A few examples are listed below.

- Pixel Genius PhotoKit – 141 simulated analogue photo effects.
- Alien Skin Exposure 3 – 500 effects that simulate the look of classic film stocks, infrared film and lo-fi cameras with non-destructive editing.
- On1 PhotoFrame – Add edges, backgrounds or darkroom effects to images or add images to album layouts.

Combining Photoshop with Lightroom

Photoshop and Lightroom are excellent tools on their own, but replacing Bridge and Camera Raw with Lightroom allows you to combine the superior performance, workflow integration and catalogue management of Lightroom with the advanced editing capability of Photoshop.

The performance of Adobe Bridge suffers when dealing with large collections of images or browsing across a network. Those are just two scenarios where the Library module of Lightroom outperforms the browsing capabilities of Bridge.

Integration settings in Lightroom control how files and their adjustments are handled when they are passed over to Photoshop. Also, round-trip features allow your edited version to automatically appear in the Library module alongside the original when you save your work in Photoshop.

- The Library module has all the capabilities of Bridge and more.
- Lightroom's Develop module is the functional twin of Camera Raw, with several interface improvements.
- The browsing and editing features are integrated seamlessly in Lightroom, while Bridge presents Camera Raw inside a separate dialogue box.
- While Photoshop has strong single-image printing capabilities, Lightroom's Print module adds the ability to print batches of images and print groups of images in layouts.

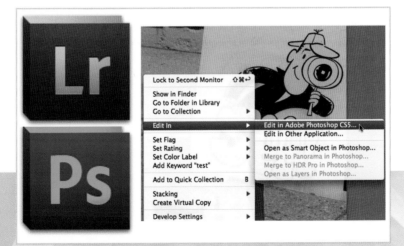

HOT TIP: Lightroom can also be paired with Elements, replacing the Photoshop Elements Organizer.

The software mentioned previously is extremely popular and effective, but there are other options that may fit your own special requirements. Some alternatives are described below.

- **Canon Digital Photo Pro** is a raw conversion utility that is bundled with Canon digital cameras. Its raw processing routines can use proprietary data in Canon raw files to produce a Canon-specific look to your images. It includes image browsing and editing tools and could be used in conjunction with Photoshop or Elements.

- **Nikon Capture NX2** is a raw conversion utility that is sold by Nikon. Its raw processing routines can use proprietary data in Nikon raw files to produce a Nikon-specific look to your images. Its image editor features a unique interface called U Control. The utility also has an image browser with file management features and can be used in conjunction with Photoshop or Elements.

- **Capture One 5 and Capture One 5 Pro** are raw conversion and image-editing workflow utilities made by studio equipment manufacturer Phase One. The Pro version is extremely popular in commercial photo studios.

- **Aperture 3** is a premium raw workflow tool from Apple. It is viewed as an advanced version of Apple iPhoto and an alternative to Adobe Lightroom.

- **PaintShop Pro X3** is a pixel-based editing tool, often referred to in the online world as 'PSP'. The software is only available for the Windows platform. Its features include a photo organiser, an 'Express' mode for quick image fixes and other more advanced editing tools. Its feature set sits somewhere between those of Elements and Photoshop.

- **Windows Live Photo Gallery** is part of Windows Live Essentials and is available for Windows only. It is an integrated tool for organising, editing and sharing images. Like Google's Picasa, it is designed for editing JPEG and TIFF files only.

One thing to keep in mind is that each raw processor has its own way of recording adjustments, so your adjustments are not 'portable'. In other words, Lightroom cannot read the adjustments you make in Aperture or vice versa. The exception to this is that Adobe has made sure raw files can move freely between Lightroom 3 and Adobe Camera Raw 6.

2 Shoot, transfer and scan

Introduction

Before there is anything to organise, enhance or share, there is capturing the image. When shooting or scanning, there are some choices to make based on your workflow and how you plan to use your photos. Smartphones are cameras, too, and we'll look at how to get photos from them and on to your computer. If you have lots of old photos, you might be interested in scanning them. We'll look at VueScan software as a model for the functionality that all scanning software has to provide in some form.

Organisation begins at the point that you scan images or transfer photos to your computer. Since you'll probably scan your files straight on to your computer, there's no transfer, but the same organisational issues apply, beginning with how you name your files. You can give your files names that are informative and add more specific, descriptive metadata in bulk as you transfer files from your camera or import them into a catalogue like Lightroom. Even though we can give our files longer names than in the early days of personal computers, it's still best to keep the names short.

Set your camera for JPEG shooting

In a sense, JPEG is the new Polaroid. When you press the shutter button, your digital image is processed in-camera. It's important to get settings like exposure and white balance right because you have limited ability to correct those things afterwards. There are a few things you can do to make your workflow easier when shooting JPEG images. In the Top 10 digital photo-sharing tips at the beginning of the book, we discussed setting your camera to number your images, which will help you maintain unique names for all of them. Here are some additional considerations.

- Choose the highest JPEG quality setting. Lower quality will allow you to shoot more images, but is also more likely to show artefacts.
- Set your colour space. Use sRGB if you are shooting photos exclusively for the Web or you want to make prints where the printer manages the colours. Use Adobe RGB if you expect to edit the images or want to make prints with the more vivid colours available in the larger colour space.
- Set the white balance. Use a preset, such as Tungsten, Daylight or Cloudy, rather than Auto. You'll get even better results if your camera allows you to shoot a neutral grey card for a custom white balance.

METADATA	KEYWORDS	
f / 4.5	1/50	3008 x 2000
	--	1.93 MB 300 ppi
AWB	ISO 200	Nikon ...0.3000 RGB

▼ File Properties

Filename	DSC_0105.JPG
Document Type	JPEG file
Application	Ver.2.00
Date Created	9/19/05, 2:43:11 PM
Date File Modified	9/19/05, 2:43:14 PM
File Size	1.93 MB
Dimensions	3008 x 2000
Dimensions (in inches)	10.0" x 6.7"
Resolution	300 ppi
Bit Depth	8
Color Mode	RGB
Color Profile	Nikon Adobe RGB 4.0.0.3000

HOT TIP: Personal photo labs, such as the Epson PictureMate and Selphy printers, can print directly from your camera's memory card and are designed to print sRGB images. Most photo printers are designed to use sRGB as the default colour space when they manage colour.

ALERT: When shooting in Adobe RGB, the colours on your camera's screen may look slightly washed out and yellowish because the camera is not colour-managing its display. Your colours will be correct in colour-managed software such as Photoshop and Lightroom. Keep in mind that you'll want to make sRGB versions of the shots to post on the Web and print with colour management to get accurate colours and take advantage of the wider gamut of the colour space.

Set your camera for raw shooting

Shooting raw files is the digital version of shooting film but, unlike film, the camera creates a JPEG preview and stores it in the raw file along with its sensor and settings data, so you have some idea of what you shot even before you process it. You process the image on your computer with software such as Lightroom, Camera Raw or the camera manufacturer's own raw conversion utility.

When you shoot in raw, you have a lot more flexibility than with other formats. Unlike shooting film or JPEGs, you can process raw files repeatedly in different ways and you can remake choices, such as white balance, after the fact. Other options when shooting raw include shooting one frame with a neutral grey target to sample the white balance later and shooting a frame with a colour target to create a custom camera profile for more accurate colour. Additional suggestions are below.

- Set your camera to automatically number your files (see Top 10 digital photo-sharing tips).
- Set the file format to raw.
- Use a preset white balance (Tungsten, Daylight and so on) or use a neutral grey card to set a custom white balance, though you can change it later.
- Set the colour space to sRGB. Don't worry – when you process raw files, the conversion utility will ignore the sRGB setting and use the raw file's internal colour space. You are doing this so that the JPEG preview will be in sRGB and present more accurate colour on the camera's display screen.

METADATA	KEYWORDS		
ƒ/5.0	1/125	2592 x 3872	
	+0.67	15.22 MB	---
	ISO 200	Untagged	RGB

▼ **File Properties**

Filename	DSC_0021.NEF
Document Type	Camera Raw image
Application	Ver.1.00
Date Created	9/30/09, 6:04:21 PM
Date File Modified	9/30/09, 5:04:22 PM
File Size	15.22 MB
Dimensions	2592 x 3872
Bit Depth	16
Color Mode	RGB
Color Profile	Untagged

ALERT: Because raw files take up so much room on your memory card, it can be tempting to delete unwanted images from your camera to free up space. This is not recommended, since it can cause files on the card to become corrupted. This can happen to JPEG images, too.

? DID YOU KNOW?

When shooting raw, there are two techniques that you can use to get the best possible colour performance from your camera. One is shooting a grey target for white balance and the other is shooting a colour chart to make a custom camera profile.

White balance is designed to imitate what our eyes do all the time: we perceive a white cloth as being white, no matter what colour light is illuminating it. White balance tries to compensate for the differences in the colour of light coming from different light sources. Generally speaking, candlelight and household light bulbs emit light in a range of yellow/orange hues, while sources such as sunlight occur in a range of blue hues. White balance works by neutralising the hue of the light source so that the photo doesn't look too blue or too orange.

A set of numbers called colour temperatures tag specific hues in the continuum between the two extremes, and each preset on your camera corresponds to one of those numbers. The numeric values come from a principle of physics and they are expressed in kelvins – a unit of temperature. Artists talk about 'warm' and 'cool' hues, but those terms relate to the way colours are perceived, so high colour temperature hues are 'cool' and low colour temperature hues are 'warm'.

Even though your camera has only one 'Tungsten' and one 'Daylight' setting, both of these types of light actually occur in a broad range of colour temperatures, so the presets are quite imprecise and may result in images that are too warm or too cool. If you shoot a test image with a neutral grey target, you can use it to compensate for the actual colour temperature of the light. Most raw workflow software has a simple eyedropper tool that allows you to click on the target in your test image and then apply the white balance to other raw files.

The key is that the target must be spectrally neutral – there are warm, neutral and cool greys. If you base your white balance on a warm grey, your image will come out cool rather than neutral. Similarly, your image will come out warm if your target is a cool grey.

A good white balance setting can eliminate colour casts, but your camera's colour performance can be further improved by creating custom camera profiles. You take a shot of a colour target, then use software to generate a camera profile from the test shot. As with white balance, you create camera profiles specific to different light sources. In Lightroom and Camera Raw, you apply the camera profile to an image in a similar fashion to applying a white balance preset.

Products like the WhiBal card and the grey card in the X-Rite ColorChecker Passport are spectrally neutral. The X-Rite ColorChecker Passport also has a colour target and software for making camera profiles that work with Lightroom and Adobe Camera Raw (you can find out more about these tools at http:mtapesdesign.com and http://xritephoto.com).

Organising and protecting your files

The next few sections will discuss various tools for getting images on to your computer. If you simply toss your images into random folders as the need arises, you're likely to quickly find that you have no idea where the photos from a particular event are stored, much less where to find the specific image you need in the next half hour. It's been said that if you only have one copy of a digital file, it doesn't really exist. If you only store those images on your computer's hard drive, it's not a matter of if but when the drive will crash and a number of your valued images are then unrecoverable.

You'll also want to think about how you name those files and folders. Even though you can use spaces on the Mac and in Windows, they can cause problems on the Web and other computer systems. There are some characters and punctuation marks that can cause problems and should not be used. There are many effective strategies to address these issues and some will be more or less appropriate for the way you work. Here are some suggestions.

- Organise your images by camera and batch.
- Use folder names as metadata.
- Abbreviate – keep file and folder names as short as possible.
- Only name files and folders with letters, numbers, dashes or underscores. Special characters such as quotes, colon, /, #, @, &, ! and so on can cause problems. So, district9.jpg is OK; district#9.jpg is not.
- Merge words or use underscores, dashes or 'inter-caps' instead of spaces in file and folder names – nospaces, no_spaces, no-spaces or NoSpaces, for example.
- Only use full stops for file extensions – so, no-spaces.htm is OK; no.spaces.htm is not.
- Use mirroring, backups and store copies off-site to protect your work.

These techniques are applied in the illustration overleaf as follows.

HOT TIP: If you want to use dates to name your folders, use the YYYYMMDD format – the year followed by the month followed by the day, such as 20100714 or 2010-07-14. That way, the folder names will sort in proper date order. Otherwise, either the days or the months will clump together.

ALERT: RAID only protects your files against hard drive crashes. You will still want to back up your files to other media to protect against file corruption and accidental deletion.

TeraNova is a RAID1 (mirroring) drive system containing two identical 1-terabyte hard drives. Whenever files are saved to the RAID, two copies are saved – one on to each of the separate drives. If one drive fails, the system gives an alert. You replace the failed drive and the system rebuilds the copies.

The Nikon D200 in this example automatically numbers files in sequence from 1 to 9999, then starts over. D200, D200b and so on each represent one complete round of numbered files. You add a new folder each time the numbering restarts. If you have more than one camera (such as a digital SLR and smartphone), each one will have its own set of folders.

The subfolders inside each batch folder represent smaller segments – the photos taken on a particular day or all of the photos from a particular shoot or event, for example. If you begin the name of the folder with the sequence number of the first image in the folder or the date, then the folders will remain in the order they were shot. The rest of the folder name is metadata – a very brief, broad description of the images inside. This is information that search tools can find, even if you never add metadata to your individual image files.

Several of the tools you can use to import your images allow you to add bulk metadata, such as your copyright information and general information about the images as you import. Once the files are on your computer, you can browse your files or view them in your catalogue software and add more metadata, either to groups of files or individual images as warranted.

With such organisation, you'll be able to retrieve that picture of a dog catching a frisbee in the park in July from your archive of 10,000 images with just a few clicks.

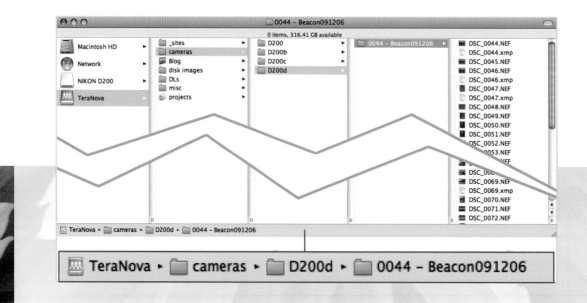

Transfer files with a card reader

Using a card reader will help keep file transfers smooth. Transfers can drain the camera's batteries and are usually much slower when you connect your camera directly to the computer.

1 Remove the memory card from the camera, place it in the card reader and plug the reader into the computer.

2 Your card will appear on your computer as an attached drive. Even though you can drag files to copy them from the card to other locations, it's best to use a utility like Photo Downloader to avoid accidentally skipping files.

3 Transfer the files from your camera or smartphone only once. It quickly becomes confusing if you transfer the same files repeatedly.

4 Importing is an opportunity to apply bulk metadata such as your copyright notice or keywords that all of the photos have in common.

5 If you're on a Mac, be sure to eject the card before you unplug the reader from the port.

6 Wait to confirm that your transferred files are OK before you clear your memory card. It might seem convenient to have the files deleted at the same time that you're moving them on to your computer, but there's always the chance that some glitch will happen.

7 To clear your card, put it back into your camera and reformat it rather than using the computer's erase command.

Import with Picasa

Picasa is well suited to a JPEG-only workflow, especially if you plan to share images primarily through Google Web Albums, Blogger or e-mail. It has an easy-to use import feature that includes the option to preview images before you transfer them to your computer. Picasa *can* display raw files, but it exhibits slow performance and cannot edit them, so it isn't a good choice if working with raw files is important.

1 Insert your media card into the reader and plug it into the appropriate port on your computer.

2 Cancel any software that might automatically start up, unless it is Picasa.

3 Click the Import button in the upper left corner of the Picasa window.

4 Use the Import from menu to locate the media card; thumbnail images will appear on the left side of the window.

5 Use the Import to and Folder title menus to select where your images will be saved. For the Folder title, you can also enter a name directly instead of using the menu options. Your imported photos will be contained within a new folder with the title you assigned. That folder will be placed inside the folder you selected with the Import to menu.

6 Recommended: set the After Copying menu to Leave card alone.

7 Optional: click an image to select and preview it on the right side of the window.

8 Optional: use the rotation buttons to change the orientation of the selected image.

9 Click Import all to transfer all images to the computer.

10 Click the X on the tab to close the import tool.

HOT TIP: Picasa has options to import only some of the images and delete images from the card once the download is complete, but it's a better idea to review the images on your computer before you delete them from the card, in case something didn't transfer properly. Once you have confirmed that the files copied OK, put the card back into your camera and reformat it, rather than erasing the files.

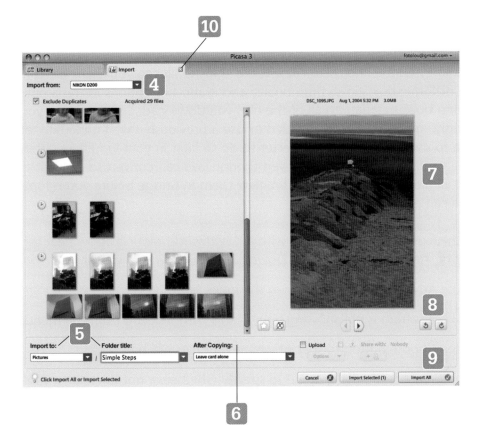

Use Photo Downloader in Bridge

Bridge launches Adobe Photo Downloader to transfer files to your hard drive. The Advanced dialogue box shows thumbnails, and it also has options for renaming files and applying bulk metadata to all of the files you download. You can enter your name and copyright info in the fields provided or use a previously saved metadata template. If you plan to use DNG format, it's better to do so later in your workflow, after you have made your initial adjustments, even though you can convert to DNG at this point. Download all files from your card and review them in Bridge before you reformat the card in the camera.

1 Click the icon showing a Camera with a downward-pointing arrow near the top left corner of the window; the Photo Downloader window will appear.

2 Click the Advanced Dialog button in the lower left.

3 If Get Photos from is not showing your media card, select it from the menu.

4 Click the Choose button to specify where your files will be saved.

5 Use the Create Subfolder(s) menu to specify whether or not to create a subfolder within the location you specified in step 4 and how it should be named.

6 Recommended: choose either Do not rename files or Advanced rename to specify a filename that extends the original filename.

7 Leave Convert to DNG and Delete Original Files unticked.

8 Optional: tick Save Copies to and click the Choose button to back up the files on to a second drive.

9 Optional: choose a metadata template to apply to all files as they are imported.

10 Click Get Photos.

> ▶ **SEE ALSO:** Renaming files is discussed in more detail in Chapter 3.

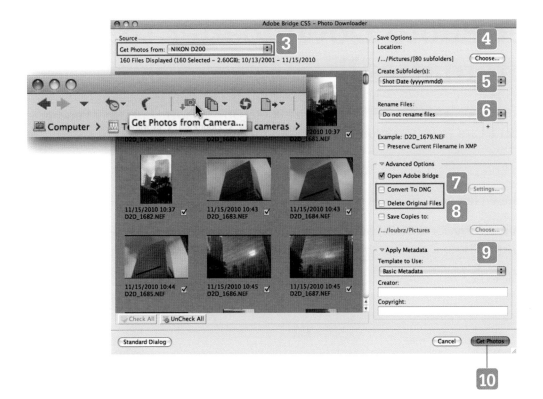

Set Photo Downloader to launch automatically

You can set a preference in Bridge so that Photo Downloader starts up whenever you connect a card to your computer, even if Bridge is not running.

1 In Bridge, select Adobe Bridge CS5, Preferences (in Windows, Edit, Preferences).

2 The Preferences dialogue box will open and display the General page.

3 In the Behavior section, tick the box labelled 'When a Camera is Connected, Launch Adobe Photo Downloader' (or untick the box to disable this feature).

4 Click OK.

Specify where Lightroom stores its catalogue

A critical difference between Lightroom and browsers like Bridge and Picasa is that Lightroom compiles a database – a kind of address book – that refers to the locations of your images. The Lightroom catalogue only contains previews of your files, not the files themselves.

When you catalogue with Lightroom, you'll be concerned with where your actual images are stored, and you may also be concerned separately with the best place to store your catalogue. By default, Lightroom, automatically stores its catalogue file on the hard drive where you installed Lightroom itself. As your collection of images grows, you may prefer to keep your catalogue on a separate drive, freeing up space on your computer's main drive.

To find out where Lightroom is currently storing your catalogue, choose Lightroom, Catalog Settings (in Windows, Edit, Catalog Settings) from the menu bar. The path to the catalogue file will appear in the window.

To create a new catalogue file in a different location, follow the steps below.

1. Select File, New Catalog... from the menu bar.

2. Use the system dialogue to select a location for your new catalogue and specify a name.

3. Click Create.

4. The current catalogue will close (this may take some time) and the new blank catalogue will open.

5. Select Lightroom, Preferences... (in Windows, File, Preferences...) from the menu bar, then click General on the navigation bar at the top of the dialogue box.

6. Set the menu in the Default Catalog section as needed. You can set it so that your new catalogue file is always loaded, have Lightroom use the most recently opened catalogue or have Lightroom ask which catalogue to use.

HOT TIP: If you already imported photos into Lightroom before you created the new catalogue, you can incorporate catalogue entries from the previous catalogue instead of having to import the photos from scratch.

Import images to Lightroom in expanded mode

Because the Lightroom Library module manages a database, its importing options are more elaborate than those of the browsing tools. Lightroom can download and catalogue images from memory cards (Copy), transfer files between drives as it catalogues them (Move) or catalogue images in their current location without moving them (Add). You can set Lightroom to make backup copies of the files as you import them into the library. While cataloguing images, Lightroom can also apply bulk metadata and develop settings. The library database can reside on one drive while the files it refers to can be stored on any number of additional drives, archived CDs or DVDs.

To handle the tasks, Lightroom has a well-designed interface that indicates from left to right where files are coming from, how they will be processed and where they are going. When you first begin importing images into Lightroom, you'll probably want to expand the default dialogue to use its advanced features, including creating presets and metadata templates. Later, you can collapse it and use the compact mode to import and update your library with just a few clicks.

When Lightroom sees that you are transferring images from a memory card, only the Copy options are available. That ensures you do not accidentally erase your only copies from the card before you have had a chance to review them to confirm they were copied properly. Once you have done that, you can put the card back into your camera and reformat it. To transfer files from a card reader, place your card in the reader, connect it to your computer, choose File, Import from the menu bar and do the following.

1 Click the button with the triangle in the lower left corner to expand the dialogue box.

2 Use the Source panel on the left side of the window to select the card reader.

3 Click on Copy in the top centre section of the window. (You can convert to DNG later, after you have completed initial adjustments and metadata.)

4 Use the Destination panel on the right side of the window to tell Lightroom where to save the files to.

5 Select Into one folder or By date from the Organize menu in the Destination panel to determine how the transferred files will be organised.

6 Optional: expand the Apply During Import panel to apply a develop preset, a saved metadata template, create and apply a new metadata template or add keywords without a template.

7 Optional: to create an import preset, choose Save Current Settings from the Import Preset menu at the bottom of the screen.

8 Click the Import button to transfer your files.

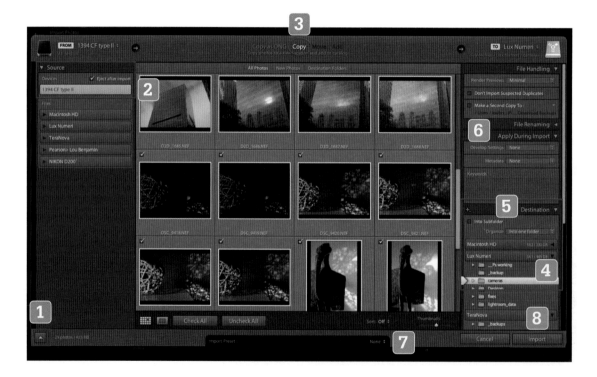

SEE ALSO: You can rename files as they are imported. See Chapter 3 for more details.

HOT TIP: To catalogue files that have already been transferred to your computer, specify the folder you wish to catalogue in the Source panel on the left side and click either Add or Move in the top centre section. If you select Move, you'll also need to specify a destination on the right side of the dialogue box.

Import images to Lightroom in compact mode

In its Show Fewer Options mode, Lightroom's Import dialogue box is designed for simple and quick imports, so it hides the thumbnail previews and panels. To open the Import dialogue box, select File, Import from the menu bar. If the dialogue box is in expanded mode, click the button with the triangle in the lower left corner of the window to collapse it.

1 Use the From menu on the top left to select a source.

2 In the top centre, click on the import method you want to use (such as Add).

3 Optional: select an import preset from the menu at the bottom of the window.

4 Optional: to update, rename or delete the current preset, choose a command from the Import Preset menu.

5 Optional: select a metadata preset and add keywords as needed.

6 Use the To menu on the top right to specify a destination.

7 Optional: specify how destination subfolders will be created.

8 Click the Import button to begin the transfer.

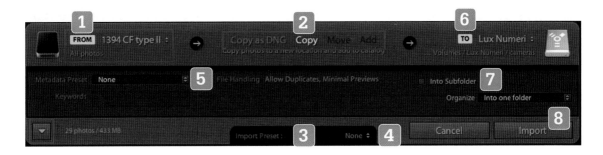

HOT TIP: In the Mac's Finder, you can drag folders and drop them on to the Lightroom icon to import them. The Lightroom icon can be in the Dock, an alias on the Desktop or in the Applications Folder window.

Download photos from your smartphone

You can use a utility that comes with your computer to download photos from your smartphone. The Mac, Windows XP, Windows Vista and Windows 7 each have different utilities, but they all allow you to connect your phone and transfer photos to a destination folder. To begin, connect your phone to the computer with the provided cable. The steps for downloading photos on to a Mac are illustrated.

1 On a **Mac**, switch to the Finder and select Go, Applications from the menu bar to open the Applications folder.

2 Double-click on Image Capture to start it.

3 Select a destination folder using the Download To menu.

4 Leave Automatic Task set to None.

5 Click Options and make sure that Delete items from camera after downloading is not ticked, then click OK to dismiss the Options.

6 Click Download All to copy all files from the camera roll.

7 In **Windows 7**, if the Autoplay window opens, click Import Pictures and Videos and continue with step 9 below; otherwise, click the Start button, then click Computer.

8 Right-click on your phone's icon and then click Import Pictures and Videos.

9 Do not use the Erase after importing option.

10 Click Import.

11 To see your saved files, click the Start button, click on [username] Folder, then click My Pictures Folder.

ALERT: Unlock your phone if you are using an iPhone with a passcode. You have to save e-mail and MMS attachments to your camera roll to download them.

Lou's iPhone

Download To: photos from iPhone **3**

Automatic Task: None **4**

Occurs after downloading

Items to download: 61

5

Options... Download Some... Download All

Options | Information

Download Options

These actions occur when items are downloaded from the camera.

☐ Delete items from camera after downloading **5**
☐ Create custom icons
☐ Add item info to Finder file comments

 HOT TIP: On Windows XP and Vista, the Scanner and Camera Wizard work in a fashion similar to Apple's Image Capture. On XP, the wizard is available under Start, All Programs, Accessories.

If you are using an iPhone with a Mac, you're likely to be guided towards using iPhoto to download photos from your phone. We are not using this approach because iPhoto does not allow you to define how images are stored and because it is only available on the Mac.

? DID YOU KNOW?

You can make your own good-quality scans with a moderately priced scanner and just a little know-how. Before we go into operating the software in the next section, it will be useful to look at some hardware issues.

If you are still shooting film, or have a lot of old images that you want to digitise, being able to do your own scanning can quickly become an asset that pays for itself. If you have negatives, slides or prints, you can convert them to digital images with a scanner. You can really scan anything relatively flat – some artists are using scanners to photograph three-dimensional objects lying on the platen.

A few points about scanners are worth covering here. There are essentially three types of scanner: flatbed, transparency (also known as slide scanners) and drum. Consumers and 'prosumers' are likely to own flatbed or slide scanners, but drum scanners are extremely expensive and are typically owned by print service bureaus.

Flatbed scanners are perfect for digitising prints and documents, though you'll get better scans from film or slides if you have them. Some flatbed models have a light source in the cover for scanning slides and negatives as well, while transparency scanners are designed to work exclusively with slides and negatives and generally offer superior performance to many flatbed scanners.

If you are looking to purchase a scanner, a key performance criterion to consider is optical resolution. Look for at least 1200 dpi resolution in a flatbed scanner and much higher if you plan to scan negatives or slides. Some scanners have different horizontal and vertical resolutions. The lower number is the relevant specification – that is, a scanner rated at 300 × 1200 dpi is effectively a 300 dpi scanner.

Special features are a second consideration. If you are going to scan a lot of film, it makes sense to get a scanner that has a proper film carrier for the formats you want to scan. That way, you'll be able to get straight scans.

To make the highest-quality colour scans for printing, it's best to have scanner software that allows you to save 16 bits per channel (48-bit) TIFF files that are tagged with a colour profile. Some scanner software does not allow you to embed colour profiles in your scans, while other software only supports the sRGB or Apple RGB colour space. You'll be able to preserve the widest gamut of colours in your scans if the software allows you to capture your scans in Adobe RGB (recommended) or ProPhoto RGB.

A look at scanning with VueScan

VueScan is an application from Hamrick Software with capabilities that might be an improvement over the software that came with your scanner. It runs on both Windows and the Mac and supports at least 1500 models, which can mean new life for older scanners with out-of-date drivers. The software is frequently updated to keep it current with operating system changes and bug fixes. The Professional Edition supports ICC profiles and colour calibration, allowing you to colour manage your images and get the most accurate colour possible. Both the Standard and Professional Editions are available at bargain prices.

The software has the following features and functions:

- Select scan resolution
- Option to scan to multiple file formats at once, such as TIFF and JPEG
- Save TIFF files in DNG format
- Embed colour profiles into your scans (you can select which colour space to use in the Pro version)
- Option to open your scan in Photoshop immediately
- Supports many model-specific features, such as transparency support, digital dust elimination and multi-sampling
- Batch scan with automatic sequence numbering.

The general steps for making scans are listed below – there is greater detail in the following sections.

1. Set your scanning preferences.
2. Adjust the input settings.
3. Adjust the output settings.
4. Set preferences for scanning to TIFF, JPEG or both.
5. Preview and scan.

Set your initial scanning preferences

1 Optional: select File, Default Options to restore the software's factory settings.

2 Click the Prefs button on the navigation bar at the top left side of the window.

3 Click the More button at the bottom of the window. The options will expand and the button will change to Less.

4 Optional: tick the External viewer box and choose an application such as Photoshop or Elements from the menu.

5 Click Crop on the navigation bar.

6 Set Crop size to Auto.

7 Click Color on the navigation bar.

8 Set Color balance to White Balance or Auto levels.

9 In the Pro version, select the Output Color space.

HOT TIP: When the External viewer option is selected, your scan will open in the selected application as soon as it is complete.

Adjust the input settings

Probably the biggest choice to make with the input settings is whether to scan in 8 bit or 16 bit. VueScan presents these choices in terms of bits per pixel, rather than per channel, so the options you see may not be what you expect.

1 Click the Input button on the navigation bar.

2 Select Scan to file from the Task menu.

3 If your scanner does not appear in the Source menu, select it.

4 Select Flatbed or Transparency from the Mode menu, as needed.

5 Select a type from the Media menu. Descreening is automatically applied when the Magazine and Newspaper options are selected.

6 For 16 bits/channel RGB, select 48 bit RGB. Select 24 bit RGB for 8 bits/channel.

7 If your media type is B/W photo, select 16 bit Gray or 8 bit Gray.

8 Select a scan resolution. Use a higher resolution if you want to be able to make larger prints. See What does this mean? opposite for more information on scanning resolution.

9 Check to see that Auto save is set to Scan.

HOT TIP: Colour files have three channels (also known as components), so a 48-bit file is 16 bits per channel. Greyscale (black and white) files only have one channel. Select either 8 bit Gray or 16 bit Gray.

WHAT DOES THIS MEAN?

A simple way to think about **scanning resolution** is to think in terms of multiples of 300. Scanning at 300 dpi produces a print the same size as the original when you print at 300 dpi. If you double the scanning resolution to 600 dpi and print at 300 dpi, the print will be twice the size of the original. So, 1200 dpi produces an enlargement of four times the size and 2400 dpi eight times and so on.

From this, it follows that you need a high-resolution scanner to produce large prints from negatives and slides. A slide scanner needs a high resolution so that you can make suitable enlargements. A 4000 dpi scanner can produce a file that will be 18 times the original size when printed at 300 dpi. That's approximately 59 × 41 cm for a 35mm slide.

Adjust the output settings

The output settings are straightforward.

1 Click Output on the navigation bar and scroll up or down as needed.

2 Click the @ button to specify a Default folder.

3 Choose Scan size from the Printed size menu.

4 Set Magnification to 100.

1

| Input | Crop | Filter | Color | Output | Prefs |

Default folder: /Users/loubrz/Picture @ **2**

Printed size: Scan size **3**

Magnification (%): 100 **4**

Auto file name: ☑

TIFF file: ☑

TIFF file name: ~can0001+_Sout

HOT TIP: Your scans will be saved in the default folder unless you override it in the TIFF or JPEG settings later.

Set preferences for scanning to TIFF

TIFF files are not quite as versatile as raw files from a digital camera, but they have a lot of flexibility compared to JPEG files, especially when you capture them in 16 bits per channel. The downside of saving TIFF files is that they are big, like raw files. A scan from a typical negative can be 60MB or more.

1. Click Output on the navigation bar and scroll up or down as needed.

2. Tick the box marked TIFF file.

3. Enter a name in the TIFF file name field. If you want to save TIFFs in a different folder from the default, click the @ button next to the name to specify a folder.

4. Set TIFF size reduction to 1.

5. For the TIFF file type, select 48 bit RGB to create 16-bit/channel files or select 24 bit RGB for 8-bit/channel files.

6. Set TIFF compression to Off.

7. Optional: tick the box marked TIFF DNG format to save your files as DNGs.

8. Tick the box marked TIFF profile. This embeds the colour profile.

SEE ALSO: When you scan several images in a batch, VueScan can automatically name and sequentially number your files for you. See the next section for more info.

WHAT DOES THIS MEAN?

VueScan has the option to save **TIFF** files in **DNG** format, so that they are automatically handled in a non-destructive workflow when you edit them with Photoshop or Elements. Adobe products treat DNG files as if they are raw files, though converting a TIFF or JPEG image to DNG does not turn it into a raw file. You can also convert files to DNG through Bridge or Lightroom.

You don't have to convert to DNG to get non-destructive editing. TIFFs are edited non-destructively whenever you open them in Lightroom or Camera Raw. See Chapter 4 for more details.

Name and number your scanned files automatically

VueScan can automatically number your files for you. Once you enter an initial filename pattern for your TIFF or JPEG files, VueScan will take it from there. You can name your scan files according to a convention similar to working with files from a digital camera. Starting with a base serial number, extend the filename with a brief description. That makes it easy to see the files in the order you scanned them and have some idea of the image even before you open it.

Consider the filename scan0001_SouthHampton_2010-08-16. It's made up of several parts:

- scan0001, scan0002 and so on are the beginning serial number
- SouthHampton describes the subject matter
- 2010-08-16 can be either the date the image was shot or the date it was scanned, in the format YYYY-MM-DD.

To have VueScan manage the numbering for you, enter the format with a + (plus sign) immediately following the initial value of the serial number. The serial number can occur in any part of the filename. Enter zeroes to hold places for digits. To create the filename you see above and have the numbers count up from there, enter the pattern scan0001+_SouthHampton_2010-08-16 in the filename field.

To continue a numbering sequence you started earlier, just enter the starting value that you want. Entering scan0075+ will continue the numbering from 0075.

Choose the TIFF file name	
Save As:	scan0001+_SouthHampton_2010-08-
Where:	TIFF
Format:	TIFF file (*.tif)
	Cancel Save

ALERT: VueScan looks at the contents of the folder where it is saving the scan files to decide what the next serial number should be. If you delete files from the folder and create gaps in the sequence, VueScan will replace the missing filenumbers. If you don't want that to happen, be sure to adjust the starting number in your filename pattern accordingly.

HOT TIP: If you begin file or folder names with the date in YYYY-MM-DD format, the years, months and days will sort properly when you order them by name. If you name them in DD-MM-YYYY or MM-DD-YYYY format, either the days or months will clump together.

Set preferences for scanning to JPEG

JPEG files are saved with lossy compression, which means that some of the data you scanned will be discarded to make the file smaller. On the other hand, JPEG files are about a tenth the size of TIFF files and are completely suitable for many applications, such as sharing on the Web and making small prints. As long as you keep the JPEG quality high, it will be hard to spot differences from a TIFF scan.

1 Click Output on the navigation bar and scroll up or down as needed.

2 Tick the box marked JPEG file.

3 Enter a name in the JPEG file name field. If you want to save JPEGs in a different folder from the default, click the @ button next to the name to specify a folder.

4 Set JPEG size reduction to 1.

5 Set JPEG quality to 100.

6 Tick the box marked JPEG profile. This embeds the colour profile.

ALERT: Do not tick the box marked Default options. It will revert some of your settings.

Preview, adjust and scan

Once you have made all of your initial settings, you can preview the scan, tweak the cropping and tone of the image and finalise the scan. If you set Photoshop as your external viewer, the image will open as soon as the scan is done. If you saved a DNG TIFF file, Photoshop will open it in Camera Raw, ready for non-destructive editing.

1 Click the Preview button at the bottom of the window.

2 Drag the lines to adjust crop edges as needed.

3 Optional:

- click Prefs on the navigation bar
- set Graph type to B/W and drag triangles to adjust black and white points
- set Graph type to Curve and drag triangles to alter contrast
- double-click either graph triangle to reset the graph
- set Graph type to Off to hide the graph
- if you are getting an odd colour cast in the white areas of your image, click Color on the navigation bar and try setting the Color balance menu to Auto levels.

4 Click the Scan button at the bottom of the window to start the scan.

5 When your scan is complete, use a preview application (such as Bridge) to confirm that you got the right results if you don't set the file to open in a viewer.

HOT TIP: When all scans are complete, you can copy or move them to other drives, make backups and import them into catalogue software as needed.

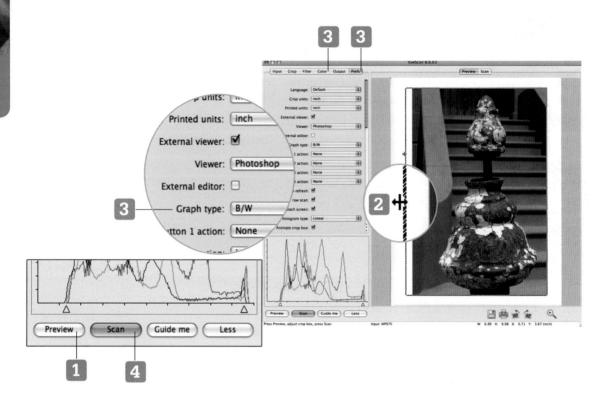

3 Organise and browse: find your photos fast

Introduction

This may sound obvious, but once you have your photos on your hard drive, you'll want to retrieve them. As simple as that sounds, it's not always a simple prospect. In selecting photos to work with, you may want to view the images at different magnifications, compare them, mark or rate them and gather them. If you know the exact folder where you placed the file you're looking for, both Windows Explorer and the Mac's Finder have decent tools for navigating to a file, previewing and opening it.

That sounds simple enough when you have 50 photos, but what if you have 5000 or 50,000? With digital, it's very easy to shoot several hundred photos in one outing. Almost all of the image-editing tools available today have file browsers or image catalogues built in or bundled with them for good reason – they offer more robust functionality than your operating system. These advanced organising tools have features that are specific to images, including better previews, rating, searching and filtering than your operating system.

Underneath it all, your files and folders are still managed by your computer's operating system. The browsing and cataloguing tools discussed in this chapter all collaborate with it, so that you can create, rename and reorganise folders and files without having to switch out of the application.

As you go through the examples in this chapter, you may notice a significant difference between managing photos with browsers like Picasa and Bridge versus cataloguing in Lightroom: your Lightroom catalogue can get out of sync with the files on your hard drive if you use the operating system or other software to move or rename files and folders. Lightroom has features to address this and its features and performance outweigh this relatively minor issue.

We'll focus on Picasa, Lightroom and Bridge in this chapter, but the principles are the same for all image management tools. If you are using something different, this chapter may give you some additional ideas on things you can do with your software.

Browse images in your operating system

There are browsing and previewing tools built into your computer's operating system. For some simple tasks, they are quicker and easier to use than the more advanced browsing and cataloguing tools that we'll look at later in this chapter, since you don't have to launch any applications to use them. The steps for browsing on a Mac are illustrated.

1 In **Mac OS X**, select one or more files in a folder and hit the space bar to open them in Quick View. In Quick View, you can switch between images with the arrow keys, play a slide show or view images as a collection of thumbnails.

2 When you open a folder, you can switch to multicolumn view. When you click on a file in this mode, a preview of the file appears in an adjacent column, along with some of the file's basic metadata.

3 You can switch the window to the Cover Flow view. It displays an array of previews that you can switch among by clicking or dragging a slider. The currently selected file is synchronised with the centremost image in the view.

4 Select one or more files in a Finder window, then hold down the Control key and press the mouse button down on one of the selected items to display a menu. Select Open With and then select the application to open the file(s) with from the menu.

5 If the icon for an image editor such as Photoshop appears in your Dock, on the desktop or in an open Finder window, you can drag one or more files to the icon to open them in that application.

6 In **Windows**, use the View menu in any Windows Explorer window to set the view mode.

7 Use the Thumbnail view to see the contents of a folder as thumbnails.

8 In any other view, click on a file to see a preview in the utility pane on the left side of the window.

9 Right-click on a file to display a menu and select an application to open it with.

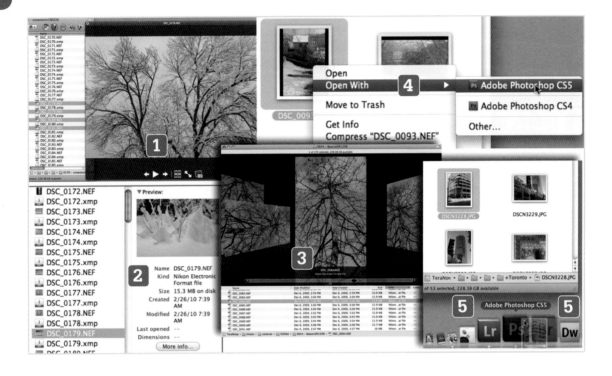

Browse in Picasa

Picasa's Folder Manager automatically rifles through every folder on your computer looking for images to list. Whenever you add images to any of those folders, it will update the contents of its folder lists. In addition to listing your computer's folders, Picasa manages albums, which can contain images from multiple folders.

1 Click a folder in the left-hand panel to show its contents in the centre panel.

2 Use the scroll bar on the right edge of the middle column to view more files in the folder.

3 Select one or more images and use the buttons in the right corner of the window to manage tags, places or people.

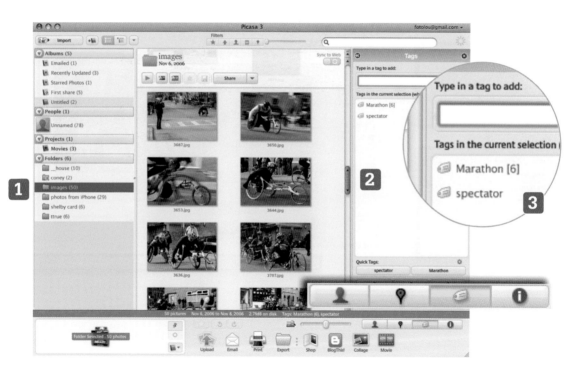

HOT TIP: If you don't want to have Picasa watch all of your folders all the time, choose Tools, Folder Manager… from the menu to control which folders appear in Picasa, which are scanned or watched, and whether face detection is used.

SEE ALSO: Tagging by faces is discussed later in this chapter.

Use key elements of Bridge

This section will briefly cover some of the more salient features of Bridge. The Bridge workspace is divided into five main areas, consisting of three vertical columns to hold panels, a header and footer. You can rearrange the Bridge interface to your liking. In the example shown, the panels have been significantly rearranged from any of the default workspace configurations to give you an idea of the options.

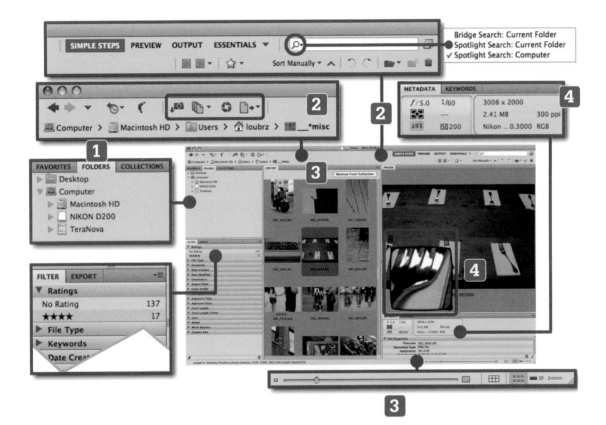

ALERT: Bridge can only browse media on volumes that are connected to the computer. When you disconnect from that network server or eject that disk, its thumbnails and previews go away.

1 Use the Folders tab to navigate the files and folders on your computer. You can save a favourite for any folder or drive from this tab and use the Favorites tab to return to them. The Collections tab contains what are essentially virtual folders. Once you create a collection, you can drag files from multiple locations into them. Use the Filter tab to narrow the selection of files appearing in the Content panel based on metadata that you have assigned, such as a star rating.

2 The left side of the header contains navigation tools. There are also buttons for Photo Downloader, the Review menu, Opening in Camera Raw and switching to the Output module. The right side contains the Workspace Switcher and the Search box. A Filter menu allows you to narrow your selection of images, while the Sort menu allows you to control the sequence of the thumbnails in the Content panel.

3 The Content panel can show thumbnails in a number of layouts. When browsing collections, it includes a button that allows you to remove images from the collection. Aside from using the Sort menu, you can drag thumbnails to sequence them. The footer contains a status line and a slider to set the size of the thumbnails.

4 You can size the Preview panel to show a lot of detail or hide it completely. When you click in the Preview panel, the Loupe tool will magnify the area around the point that you clicked. The Metadata and Keywords panels allow you to view and manage descriptive data attached to your files.

? DID YOU KNOW?

It's beyond the scope of this book to go into much detail on the functionality of Bridge. You can read about Bridge in much greater detail in Chapter 2 of *Photoshop CS5 in Simple Steps*, also by Louis Benjamin (Pearson Prentice Hall, 2010).

Browse in Bridge

You can use the Folder panel, perform a search or click on a collection to view a set of thumbnails in the Content panel of Bridge.

1 Click on a thumbnail to view it in the Preview panel and hit the space bar for a full-screen preview. Hit the space bar again to exit full screen.

2 Click in the Preview panel to activate the Loupe tool. (There may be a slight delay while the tool starts up.) Drag the Loupe to view different parts of the image. Click on the Loupe again to put it away.

3 Drag images to sort manually or use the Sort menu.

4 To rotate images, click on the image and then click the Rotate icons in the Path bar or use Command/Ctrl + [to rotate counterclockwise and Command/Ctrl +] to rotate clockwise.

5 Click on the items in the Filter panel to show or hide thumbnails in the Content panel. A tick appears next to active filters. Click on the item again to switch it off. You can also activate multiple filters at the same time.

6 To select more than one image, click the first thumbnail, then Shift-click on another to select it and all images between the first and second; or Command/Ctrl-click each additional image that you want to select. You can also Command/Ctrl-click to deselect one of several images that have already been selected.

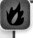 **HOT TIP:** There is a handy shortcut to point at a folder in the Mac's Finder or Windows Explorer and browse it in a Bridge window. On the Mac, drag the folder to the Bridge icon in the Dock, on the Desktop or in an open window to browse it. On Windows, right-click on a folder and select Browse in Adobe Bridge CS5 from the menu that appears.

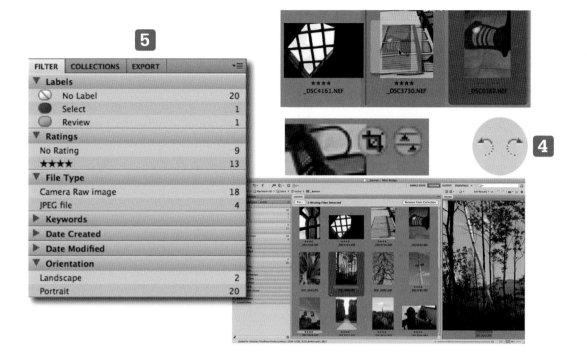

HOT TIP: Sometimes, all you need to find an image quickly is a layout with lots of thumbnails. If you hit the tab key, Bridge will expand the current Content panel and hide away all others. Hit the tab key again and you return to the previous view.

A look at the Library module in Lightroom

The Library module is where you browse and organise your catalogue and select files to work with in the other modules. The Library provides several views to assist in evaluating and enhancing images.

1 The panel group on the left includes the Navigator panel, the Catalog and Folders panels for selecting groups of images, the Publish Services panel and the Import and Export buttons.

2 The Preview area in the centre shows images in either Grid view or Loupe view. When the Grid view is active, the Library Filter controls appear at the top of the area.

3 The Toolbar appears immediately below the Preview area.

4 Use the Module switcher on the top right to go to Lightroom's other modules.

5 The panel group on the right includes the Histogram, Quick Develop, Keywording, Keyword List, Metadata and Comments panels. The Sync and Sync Settings buttons at the bottom allow you to apply metadata and settings from one image to several others in one easy process.

6 The Filmstrip appears at the bottom of all modules and has two parts: a row of buttons and menus across the top and a row of small thumbnails below. The Filmstrip thumbnails show all of the photos from the current source – the selected catalogue, folder or collection with any filter applied.

7 Use the menu towards the top left of the Filmstrip to switch between recent sources and favourites.

Browse in Lightroom

You browse for files in the Lightroom Library module. Click Library in the upper right corner of the Lightroom window to enter the module.

You can browse your entire library at once, view the contents of a specific folder or make selections that span folders. You can flag files as picks or rejects, then use the Library Filter to see only flagged files. Flags are part of the current folder or collection – the same file can be flagged as a pick inside a *folder* and as a reject inside a *collection*.

1 Tap the G key to enter the Grid view.

2 Tap J repeatedly to cycle the Grid view style.

3 Click the triangles on the Folder panel (left side of the window, beneath the Navigator panel) to collapse or expand them.

4 To view a selection of files, do any of the following:
- click a folder in the Folders panel to view its contents
- Shift-click or Command/Ctrl-click additional folders to view the contents of several folders together
- click one of the items in the Catalog panel, such as Quick Collection
- click an item in the Collections panel, such as Smart Collections > Five Stars
- select an item from the Sources menu at the top of the Filmstrip.

5 Drag the Thumbnails slider on the right side of the toolbar to adjust the size of the thumbnails.

6 Click in the grid area to select an image. Optional: Shift-click on a different photo to select all photos between the two or Command/Ctrl-click on photos to individually select additional photos.

7 Optional: tap P to flag selected files as a pick or U to unflag them.

8 Optional: tap X to flag selected files as a reject or U to unflag them.

9 Optional: click on Attribute in the Library Filter bar to view files by flags, star ratings or colour codes. Click on None to remove the filter.

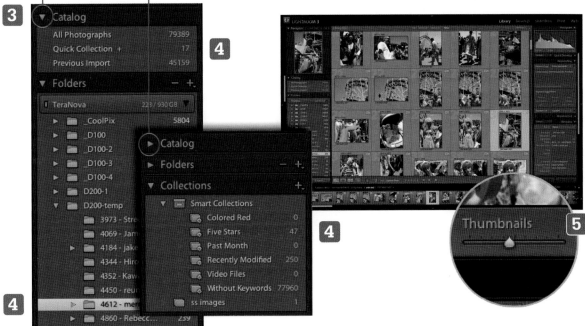

Evaluate an image in Lightroom – the Loupe view

There are times when the thumbnails in the Grid view are too small to determine whether or not a photo is any good. In that case, you can use the Loupe view to zoom in to get a closer look.

1 Double-click on an image in the Grid view or hit the space bar to view it in the Loupe.

2 Click in the image to zoom in; click again to zoom back out.

3 When the image is zoomed, drag inside the display area to see a different area of the image.

4 Optional: click or drag inside the Navigator panel (top of the left-hand panel) to activate and position the Loupe view.

5 Optional: click 2:1 or select another zoom level from the double-triangle menu at the right edge of the Navigator panel. Clicking in the image will now alternate between fitting the screen and zooming in to this level. Click 1:1 to return to the default zooming behaviour.

6 Optional: select View, View Options… from the menu bar to adjust options for the Info Overlay.

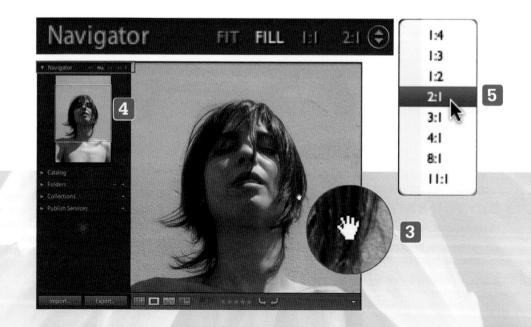

Evaluate an image in Lightroom – the Compare view

If you have two images that are similar, you can bring them up on screen side by side to determine which you prefer. The active image has a white border around it and can be either image.

1 In the Grid view, select two photos – click the first one to select it, then Command/Ctrl-click to select the second one.

2 Tap C on your keyboard or select View, Compare from the menu bar to enter the Compare view.

3 Click on either image to activate it. A white border will appear around it.

4 Tap P to flag the image as a pick, X to flag it as a reject or U to unflag the active image.

5 Tap the number keys 1–5 to set rating stars for the active image or tap 0 (zero) to remove stars.

6 Click or Drag in either image or use the Navigator panel to zoom and view different parts of the two images.

7 Dragging either image in the view normally moves and zooms both together. To align similar areas of the two images, do any of the following:
- click the Lock icon on the toolbar to unlink the two images
- optional: drag either image into position
- optional: adjust the zoom level of either image
- click the Lock icon again to relink the images
- optional: click the Sync button to return the linked images to their default alignment.

8 To change the Select and Candidate images, do any of the following:

- use the Swap or Make Select buttons on the toolbar to change which image appears on the left
- use the arrow buttons on the toolbar to load a different image to compare to the Select
- click images on the Filmstrip to change either the Select or the Candidate. A black diamond appears in the upper right corner of the Candidate.

9 Click Done on the toolbar to return to the Loupe view or tap G to return to the Grid view.

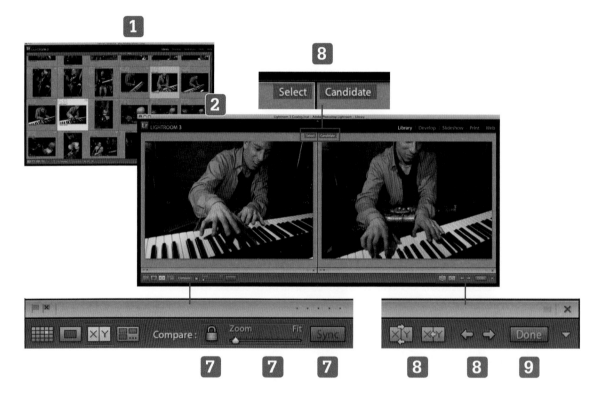

Evaluate and compare images in Bridge

The evaluation and comparison tools in Bridge are similar to those in Lightroom, but they are not as robust.

1 Click an image in the Content panel to select it.

2 Tap the space bar to go into a full-screen view.

3 Click the full-screen view to zoom in or zoom out. When zooming in, the area you clicked will remain in view.

4 Drag the zoomed view to see other parts of the image.

5 Tap Command/Ctrl + 1–5 to assign star ratings and Command/Ctrl + 0 (zero) to remove stars.

6 To compare images, select two or more images in the content panel. They will appear together in the Preview panel.

7 Optional: resize the Preview panel as needed to see larger views.

8 Optional: click in either image in the Preview panel to open the Loupe tool for that preview.

- Click a different part of the image or drag the Loupe to reposition it.
- Click the Loupe to close it.

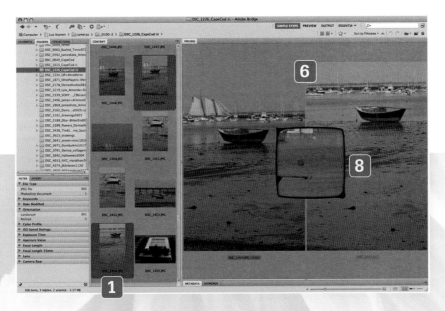

Name files systematically

Filenames are metadata, so let's take advantage of that fact by putting useful data into the name of each of your files. It's also important that each filename be unique. If you look around the Web or at other books, you're likely to see that there is some disagreement about renaming files. Some will tell you that you shouldn't rename your files at all, while others will tell you that you should completely change the name. The approach taken here is to build on a good thing by extending the sequentially numbered filename that your camera gave you.

This discussion expands on the same naming convention presented in the scanning section of Chapter 2. Where scanner software gives you the latitude to name each file individually, most cameras will at least number every file sequentially and many allow you to set a file prefix of three characters or so. The result is that you'll start with files that have names like IMG_1234.JPG or D2B_7890.NEF. You can use a batch renaming tool, like the ones found in Bridge or Lightroom, to retain the sequential number part of the file and replace or add more useful text before and after it. The naming scheme we'll use here is:

Camera code + sequence number + descriptor

You can use the naming software to replace the generic 'IMG' at the beginning of the filename with a more indicative camera or source code, like SP1 (for smartphone series 1). Another possibility is that you could expand the three-character prefix to something more readable, such as replacing 'D2B' with D200B (for Nikon D200 series B). The descriptor at the end of the name could be anything brief that describes the set of images, such as 'Halloween2010'. The resulting files in each case would be SP1_1234_Halloween2010.JPG and D200B_7890_Halloween2010.NEF.

With these changes, we achieve three things:

- the filename indicates which camera the images came from and, by adding the 'B' designation, it even indicates that this photo was shot after the first 9999 photos were taken with the camera and the counter restarted at 0001

- the names of the files still indicate the order in which they were shot
- a simple text search would now allow you to find your Halloween2010 photos.

If you only rename the files using a camera code and the sequence number assigned by the camera, the filenames will still be unique, so that you won't have the problem of two or more completely different images named DSC_4596 floating around your hard drive.

You can expand this scheme further as needed. One possibility is to add your initials to all of your filenames. That way, it's just there and you don't have to think about it when you make a JPEG file that you're sending off to someone else.

Preview

Current filename: **DSC_1449.JPG**

New filename: **D2B_1449_CapeCod_20040802.JPG**

 2 files will be processed

HOT TIP: Adobe's batch renaming tool gives you the chance to record the original name of the file in its metadata so that at least you can refer back to it if you need to.

ALERT: Some cameras come from the factory with the counter set to restart from 0001 each time you reformat the media card. Be sure to find the setting that causes the camera to continue counting on when you empty the card or use an extra one.

Use Batch Rename in Bridge

The Batch Rename tool in Bridge allows you to transform the names of a selected group of files in a number of incremental steps. The options in the Rename dialogue box are very flexible, but the meaning and use of some of the options take some getting used to. You can save the procedure as a preset to be reused as needed. Once you have defined a preset, you simply choose it from the menu at the top of the dialogue box and click Rename.

In this example, we'll look at how we can enhance the names of files that came from a smartphone. The phone saves photos in the sequential format IMG_0001.JPG, IMG_0002.JPG and so on. We want to change the files' prefix from IMG to SP1 and add some text that helps describe the files and add the date created to the end of the file. Underscore characters will be used to separate the parts.

1 Select the files you wish to rename.

2 Select Tools, Batch Rename from the menu bar.

3 Select the destination folder. If you select Move to other folder or Copy to other folder, click Browse... and use the dialogue box to create a new folder or open an existing folder and click Choose.

4 Use the New Filenames section to specify how the filename will be transformed. A preview at the bottom of the dialogue box will update as you work. Click the plus (+) or minus (−) buttons as needed to add or remove lines.

5 In the first line, select Current Filename from the leftmost menu, then choose Name from the middle menu.

6 In the second line, choose String substitution from the leftmost menu, then choose Intermediate filename from the middle menu.

7 Type 'IMG' in the field marked Find and 'SP1' in the field marked Replace with.

8 Tick the box marked Replace All.

! ALERT: Preserving the original filename is not foolproof. If you Batch Rename the same file twice, the original file name will be lost.

9 In the third line, choose Text from the menu on the left and enter a brief descriptor into the adjacent field.

10 In the fourth line, select Date Time from the leftmost menu, Date Created from the centre menu and YYYYMMDD from the rightmost menu.

11 Set the preserve and compatibility options as needed and confirm that the preview is showing the result you expect.

12 Optional: for further confirmation of the name conversions, click the Preview button and review the results in the dialogue box.

13 Optional: click Save… to enter a name for your preset and click OK.

14 Click Rename to process the files.

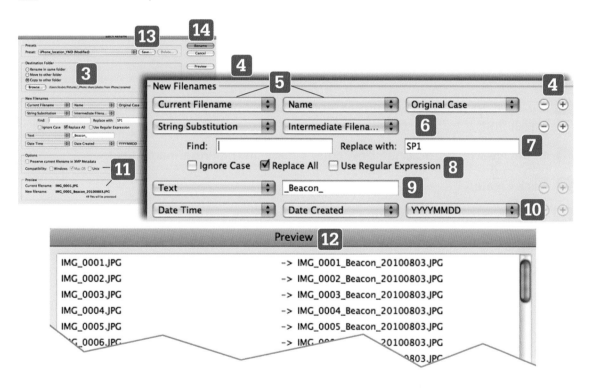

HOT TIP: This example shows how to use Batch Rename with string substitution but, since you're replacing the entire first part of the filename, you could get the same result in this case by starting with the text 'SP1_', then selecting Current Filename from the left menu and Number Suffix from the middle menu on the second line.

Rename files in Lightroom

In Lightroom, you apply a reusable template to rename files. Templates consist of plain text that you type in along with tokens that you add via menus and buttons. The tokens are coloured placeholders with rounded ends that represent metadata from the files you are renaming. You can create a template from scratch or select an existing preset, then alter it.

1 Select Library, Rename Photo from the menu bar. A dialogue box will appear.

2 Choose Edit from the Template menu. A second dialogue box will appear.

3 Optional: choose an item from the Preset menu.

4 Click in the text box to enter static text.

5 Use the menus and the Insert button to enter tokens.

6 Click a token and hit the Delete/Backspace key to remove it.

7 Optional: to save your settings as a preset, select Save Current Settings as New Preset from the Preset menu.

8 In the New Preset dialogue box, enter a name in the Preset name field.

9 Click Create.

10 To finish renaming, click Done to exit the template editor.

11 Click OK to execute the process.

HOT TIP: The same template editor dialogue box and renaming options are also available when you import or export files.

Rename folders in Bridge or Lightroom

You can rename folders via the Folders panel of either Bridge or Lightroom.

1 Click to select a folder.

2 Control-click/right-click on the folder to display a menu.

3 Choose Rename.

4 Type a new name and hit Return/Enter to commit the change.

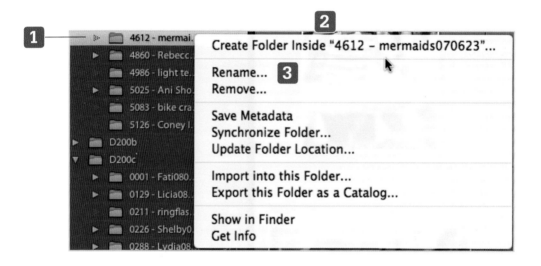

HOT TIP: If you need to rename folders that have been catalogued in Lightroom, it's best to do it from within Lightroom. If you rename the folder outside of Lightroom, the catalogue will need to be updated to recognise the images being referenced.

Create a new folder via Bridge

You can create folders in Bridge for convenience – it saves you from having to switch to your operating system to do so. Since Bridge is simply a browsing tool, there is no difference between creating folders from within Bridge and doing so from the operating system.

1 In the Folders panel, select a folder or drive to contain your new folder.

2 Control-click/right-click on the selected folder to display a contextual menu.

3 Select New Folder from the menu; your new folder will appear in the Content panel.

4 Edit the folder name as needed.

Add a folder to Lightroom

When you add folders that already exist on your hard drive to the Lightroom Folders panel, Lightroom will catalogue the files within it. When you create a new folder via Lightroom, the folder will be created on your hard drive and added to the Folders panel.

1 Optional: to create a subfolder, select an item in the Folders panel to contain the new subfolder.

2 Click the + icon and choose Add Folder... or select Add Subfolder...

3 Use the file dialogue box to navigate to the folder you want to add.

4 Click on the folder and then click Choose/OK.

5 If the Import Photos dialogue box appears, select your options and click Import.

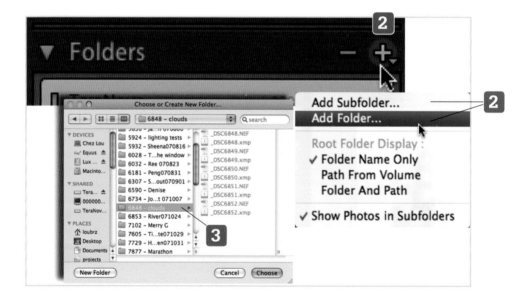

HOT TIP: To create new folders or subfolders, click the New Folder/Make New Folder button in the file dialogue box or select Add Subfolder from the + icon menu. When you create a subfolder, you have the option to copy the selected images to the new folder.

ALERT: If you create a folder from within Lightroom and add images to it through some other application, you'll need to synchronise the folder in Lightroom to see the images in that folder. See the next section for more details.

Synchronise Lightroom's folders with those on your hard drive

If you import a folder to your Lightroom catalogue and then add more files to that folder outside of Lightroom, the new photos will not automatically appear in Lightroom. Similarly, files that have been deleted outside Lightroom will still appear in the catalogue until you remove them. The Synchronize Folder command allows you to update your catalogue with control over what gets added or removed. It can also be used to update metadata changes made outside of Lightroom.

1 Select a folder in the Folders panel.

2 Control-click/right-click on the folder to show a menu and select Synchronize Folder... or select Library, Synchronize Folder... from the menu bar.

3 To import new images into the catalogue, tick the box marked Import new photos.

4 Optional: tick the box marked Show import dialog before importing to specify which files are imported.

5 Optional: tick the box marked Remove missing photos from catalog.

6 Optional: tick the box marked Scan for metadata updates.

7 Click the Synchronize button.

8 If the Import Photos dialogue box opens, tick the files and folders that you want to import and untick the ones you do not want. Click Import after you have made your selections.

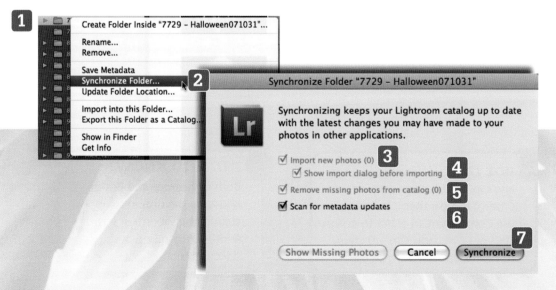

Apply star ratings

Picasa only has a single star/no star option, but Lightroom and Bridge allow you to rank files from zero to five stars. The illustrations show the steps in Lightroom.

1 In **Lightroom**, tap G to enter Grid view.

2 If you do not see stars on the toolbar, click the triangle at the right edge of the toolbar and select Rating from the menu.

3 Select one or more files.

4 Click on a rating star on the toolbar.

5 To clear a rating, click the rightmost star on the toolbar or choose Photo, Set Rating, None from the menu bar.

6 In **Bridge**, set the Content panel to Thumbnail view.

7 Select one or more thumbnails and increase the scale of the thumbnails until dots appear beneath the selected thumbnails.

8 Click the dot corresponding to the star rating you wish to assign. The dots will change to stars.

9 To clear ratings, click immediately to the left of the stars beneath a thumbnail or select Label, No Rating from the menu bar.

HOT TIP: In Lightroom, you can also tap 1–5 to assign stars or tap 0 (zero) to clear them. In Bridge use Command/Ctrl + 1–5 to assign stars or Command/Ctrl + 0 (zero) to clear them.

? DID YOU KNOW?

Both Lightroom and Bridge also have the option to apply colour labels to images as another organising and selection tool.

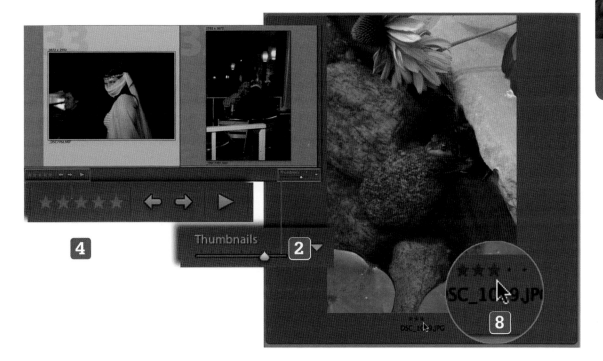

4

Thumbnails **2**

8

Flag photos in Lightroom

There are three flag states – photos can be unflagged, picked or rejected. Flags remain inside the folders or collections where they were assigned, unlike star ratings – where a three-star photo has three stars no matter where it is. If you flag files inside a folder and then make a collection that includes those files, those photos will not be flagged in the collection. You can assign completely different flags inside the collection and they will not affect the flags in the folder. If one of your photos appears in several collections, it can have different flag states in each one.

1 Switch to Grid view.

2 Select one or more photos.

3 Tap P to quickly tag the selected images as a Pick or tap X to reject.

4 Alternatively, click the desired flag on the Library toolbar.

5 Another way is to choose Photo, Set Flag from the menu bar and select a flag state from the options presented.

6 You can also set flags by clicking in the thumbnail cells of the Grid view. To enable this feature, do the following. Choose View, View Options from the menu bar; the library View Options dialogue box will appear.

7 Select the Grid View tab.

8 Make sure that Flags is ticked.

Tag by faces in Picasa

Picasa scans your images for faces and compiles a list of them as it reads the contents of your folders. You can name those faces, then click on the people to select the photos containing them.

1 Click the People icon at the lower right to assign names to the faces that appear in the selected folder.

2 Click the X box on a face to ignore it.

3 Type a name into the Add a name box and hit Return/Enter to add a new person.

4 When the People dialogue box appears, click New Person to add them.

5 Update the name, nickname, e-mail and sync options as you wish.

6 Click OK. That face will appear in the panel on the left under People.

7 Click a person in the left-hand column to select photos containing that person.

Use map locations in Picasa

Some smartphones automatically geo-tag photos with the locations where they were shot as part of the image metadata. The Places feature lets you edit geo-tags and add them to photos that don't have them.

1 Click Places at the lower right.

2 To assign a location to the selected image(s), type an address into the search box, hit Return/Enter and click OK when the Put photo here? dialogue box appears.

3 Alternatively, click the green pin button and click on the map to place the photos. Click OK when the Put photo here? dialogue box appears.

4 Click the red map pins to see the photos associated with them. You will have the option to erase the location data.

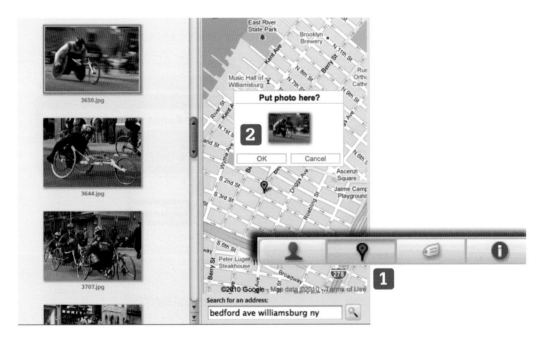

? DID YOU KNOW?

You can attach a GPS device to some digital cameras so that its photos are automatically geo-tagged. There is also software available that allows you to geo-tag photos by matching them up with a log file that you can download from many GPS devices.

Filter in Bridge

When you browse a folder or collection in Bridge, the Filter panel automatically compiles a list of metadata for the current set of files, including file type, ratings, keywords and more, by category. Select items in the Filter panel to view only those files bearing those particular attributes.

1 Click one or more items in the Filter panel to select files with those attributes. A tick mark will appear to the left and only the items with that metadata will be visible in the Content panel.

2 Click more items in the Filter panel to add selection criteria. Selecting criteria from the same category (such as three- and four-star ratings) shows additional files. Selecting across categories (such as two-star and File Type JPEG file) shows only files that have both chosen attributes.

3 Click a ticked item to remove the tick mark. When none of the items in the list is ticked, the original unfiltered set of files is restored.

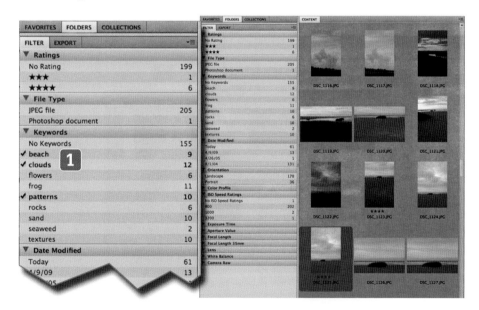

HOT TIP: Shift-click a star rating in the Filter panel to select all files with that rating or higher. For example, shift-click three stars to select files with three, four or five stars.

Filter by text in Lightroom

The Library module features a Filter bar at the top of the Grid view. You can set the bar to filter by Text, Attribute (such as flag or star ratings) or Metadata (such as file type or camera).

Combine text or attribute with metadata. A text search allows you to search for a fragment of a phrase. Multiple phrases can be entered, separated by commas. Filter bar settings can be saved as presets.

1 Click on Text on the Filter bar and enter all or part of a word or phrase you want to match in the search box.

2 Optional: select a searchable field or select Any Searchable Field from the menu on the left.

3 Optional: select a search rule (Contains, Starts with and so on) from the second menu to specify which results match the criteria.

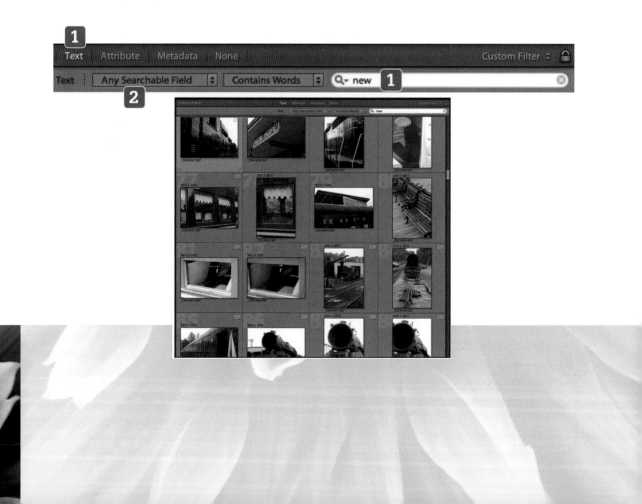

Filter by attribute in Lightroom

Lightroom's Attribute filter can select photos based on flags, star ratings and colour labels. It can also separate master photos, virtual copies, even videos. The Library Filter menu allows you to save and reuse filters.

1 Click on Attribute on the Filter bar.

2 Optional: click one or more flag icons to select files with that flag. Click the flag again to cancel the filter.

HOT TIP: You can also create Smart collections based on the criteria specified on the Filter bar.

3 Optional: click a star to select a star rating:

- click the rightmost star to remove the star filter
- hold the mouse button down on the symbol between the Rating label and the stars for a menu to determine whether the filter will include images with greater or lesser star ratings.

4 Click the lock icon to retain the filter settings and apply them to all subsequent folders or collections that you select until you click to unlock the icon.

5 Use the Custom Filter menu near the right edge of the Filter bar to save your selection as a preset or to use an already saved preset.

6 Click None to switch off filtering.

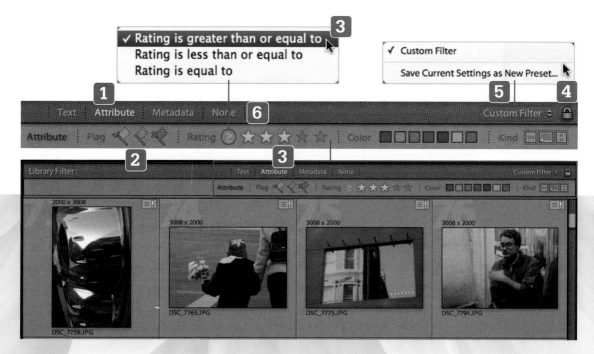

Filter by metadata in Lightroom

Beyond keywords, labels and copyright-related metadata that you can embed into your photos, Lightroom keeps track of metadata embedded by your camera and computer. You can filter by up to eight levels of metadata by creating columns and selecting which field that column filters. The columns are applied from left to right, with each subsequent column further constraining which images will be shown.

1 Click Metadata on the Filter bar.

2 Hold the mouse button down on a column title to display a menu and select which metadata field the column will filter, such as keyword, lens, focal length and aspect ratio.

3 Hold the mouse button down on the right side of a column header to display a menu to add or remove columns or else change the view or sort the column contents.

4 Click an item in the column to filter by that value.

5 Use the Custom Filter menu near the right edge of the Filter bar to save your selection as a preset or to use an already saved preset.

6 Click None to switch off filtering.

? DID YOU KNOW?
You can combine metadata filtering with attribute or text filtering. Filter bar settings can be saved as presets, so you can even set up complex filters and reuse them with ease.

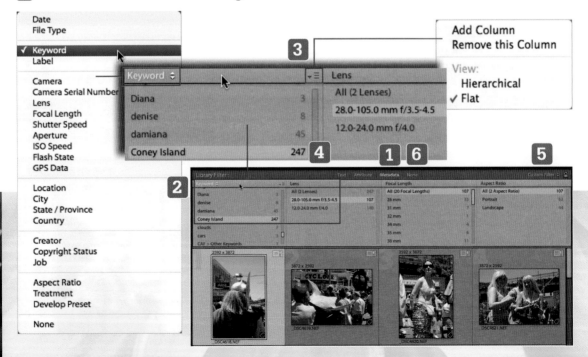

4 Basic editing and image tuning

Introduction

Many photos can be improved significantly just by removing red-eye, blemishes or spots or straightening or cropping the scene. Other basic fixes include adjusting the colour. These are all tasks that raw editors like Lightroom and Camera Raw are able to perform easily on both raw files and JPEG images. Picasa and many other editors can also do the same for JPEG files.

In this chapter, we will focus on Picasa, Lightroom and Camera Raw, but the principles apply to many other tools. Even though Adobe has built both Camera Raw and Lightroom with the same processing engine, there are some differences in the way the two interfaces work that go beyond cosmetics and labelling. In the cases where the differences are significant, we'll look at how the tasks are performed in both environments; otherwise, the differences are small enough that you should be able to translate the examples between the two.

Edit photos with Picasa

Editing JPEG images in Picasa is simple and straightforward. It has a range of tools that are helpful for correcting colour and tone, as well as minor retouching and applying effects such as converting to black and white or sepia toning.

Picasa's editing tools are non-destructive. You can undo individual edits and also reset the image to its original state.

1 Double-click on an image in the Library to enter Edit view.

2 Use the tabs on the left to access adjustment tools.

3 Click the X in the circle at the top of the panel on the right to hide it and free up space. Select View, Tags to show the panel.

4 Use the slider beneath the image area to zoom in or out. This can be helpful for use with tools like Retouch and Redeye. Drag inside the image area or drag the rectangle in the zoom thumbnail to reposition the view.

5 If you have made a lot of edits and want to start over or simply discard your changes, select Picture, Undo All Edits from the menu bar to revert to the original.

6 Control-click/right-click in the image area to show a menu of options, including Undo all Edits.

7 While in the Edit view, click a thumbnail or one of the navigation arrows above the image area to switch to another image.

8 Click Back to Library to return to the Library view.

9 Use Edit, Copy All Effects and Edit Paste All Effects from the menu to copy effects from one photo and apply them to one or more photos in the Library or the Edit view.

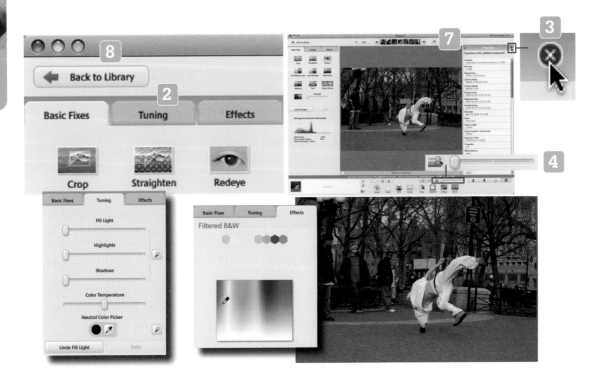

Edit photos with Picasa – the Basic Fixes tab

Double-click on an image to begin editing it in the Basic Fixes tab.

1. Use Crop and Straighten to adjust the alignment and shape of the image. After you apply a crop, the button is labelled Recrop.

2. Use Redeye and Retouch to fix issues with the appearance of people in your photo.

3. Use I'm Feeling Lucky to apply a one-click automatic fix for lighting and colour.

4. Use Auto Contrast and Auto Color to adjust lighting and contrast individually.

5. Move the Fill Light slider to lighten the darkest areas of your image. Return it to the extreme left to undo it.

6. Click the grey text area beneath the image to enter a caption and hit Enter/Return to commit it.

7. Click the bin icon to the right of the caption to remove it. Use the button to the left of the caption to hide or show it. Click the Text icon and click inside the image to place styled text over it.

8. When you activate the Crop, Straighten, Redeye, Retouch and Text tools, they each provide buttons to apply or cancel the effect.

9. Once one or more adjustments have been applied, use the Undo or Redo buttons as needed. To remove all text, click the Text tool, click on Clear All, and then click Apply.

10. Click a thumbnail in the top centre of the window to begin working on another image or click Back to Library in the upper left corner of the window to exit the editing tools.

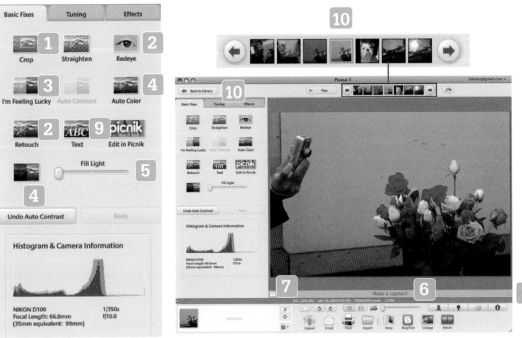

HOT TIP: If you need to straighten your image and fix red-eye, apply the Redeye tool first. It can have problems with alignment if you try to apply it after you have used the Straighten tool.

Edit photos with Picasa – the Tuning tab

Use the Tuning tab to adjust issues with colour and lighting. The Fill Light control from the Basic Fixes tab appears in this tab, too.

1 Use Fill Light to lighten just the darker areas of your photo.

2 Use the Highlights slider to lighten the brighter parts of the image.

3 Use the Shadows slider to add more weight to the darkest parts of your image.

4 Click the button to the right of Fill Light, Highlights and Shadows to apply a one-click fix for lighting. This button automatically adjusts the three sliders.

5 Use the Color Temperature slider to make your photo more yellow or blue, as needed to compensate for the colour of the ambient light.

6 Optional: click the Neutral Color Picker's eyedropper icon, then click an area of the image that is supposed to be a neutral grey to adjust the colour. Alternatively, click the button to the right to apply a one-click colour fix.

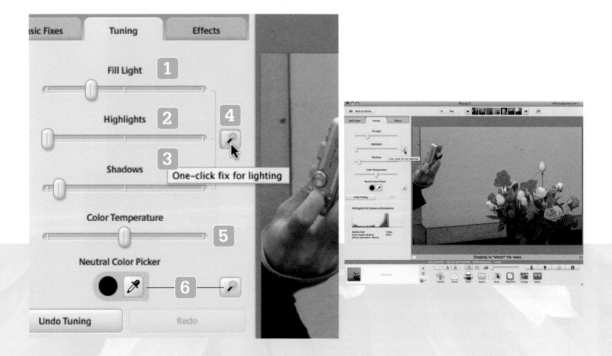

Edit photos with Picasa – the Effects tab

Click the buttons under the Effects tab to apply them.

1 Sharpen, Tint, Saturation, Soft Focus, Glow and Graduated Tint have sliders to control the adjustment.

2 Filtered B&W has a colour picker that allows you to emphasise certain tones in your black and white image. Click Pick Color and move the mouse pointer over the colours for a preview. Click a colour to select it.

3 To use Focal B&W, click in the image to select a focal point that will appear in colour. Use the Size and Sharpness sliders to control the transition to black and white.

4 Click Apply or Cancel to apply the effects listed above or discard the changes.

5 Simply click the other buttons to apply them.

6 The Undo button at the bottom of the tab will undo the effects you have applied in reverse order.

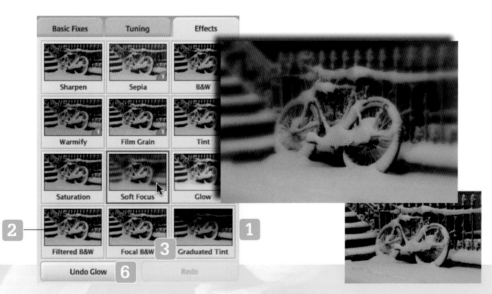

HOT TIP: Sepia, B&W, Warmify and Film Grain can be applied multiple times. Clicking those buttons repeatedly changes the effects by degrees. Each click has its own separate Undo.

Use Lightroom's Develop module

If you're working with Lightroom, you'll do some initial organising in the Library module, then you'll probably use the non-destructive editing tools in the Develop module to enhance some of them. This section is an overview of the features in the Develop module. Some features will be covered in greater detail later in this chapter.

The Develop module and Camera Raw are built on the same processing engine, so you can edit files interchangeably in either environment. This is especially helpful if you start with Photoshop and decide to use Lightroom later to manage your photos.

The central image area has a toolbar beneath it. The Navigator, Presets, Snapshots, History, and Collections panels are grouped on the left. On the right are the Tool Strip and adjustment panels. The filmstrip appears at the very bottom of the window.

1 Loupe.

2 Before and After view modes.

3 Navigation arrows.

4 Zoom.

5 Show/Hide tools menu (click the triangle).

6 Navigator panel.

7 Presets, Snapshots and History.

8 Collections.

9 Histogram.

10 Tool Strip, including Crop and Straighten, Dust and Spot Removal, Redeye Correction, Graduated Filter and Adjustment brush.

11 Adjustment panels.

12 Filmstrip.

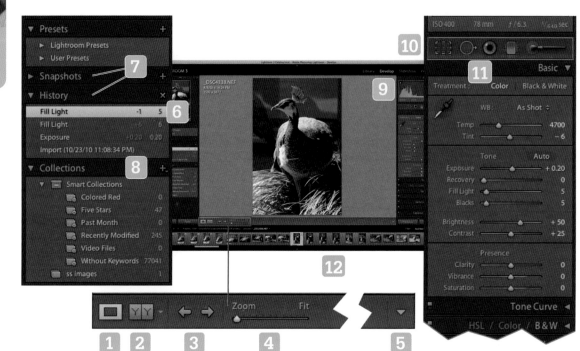

HOT TIP: **HOT TIP:** The Quick Develop panel in the Library module manages the same adjustments as you see in the Develop module, but the controls only offer coarse adjustments.

Set preferences for Camera Raw

Camera Raw is a plug-in, which means it is available as an on-demand resource inside both Photoshop and Bridge; there is no separate application to launch. You can adjust your Camera Raw preferences from either application.

You'll need to set your preferences once, then update them only as the need arises. Advanced users may have specific reasons to diverge from the settings recommended below, but these general-purpose settings will suit a wide range of uses.

1 In Bridge, select Adobe Bridge CS5, Camera Raw Preferences... (in Windows, select Edit, Camera Raw Preferences...).

2 In Photoshop, select Photoshop, Preferences, Camera Raw... (in Windows, select Edit, Preferences, Camera Raw...).

3 In the General section of the dialogue box, set Save image settings in Sidecar ".xmp" files and set Apply sharpening to Preview images only.

4 In the default Image Settings section, it's best to only tick the box marked Apply auto grayscale mix when converting to grayscale.

5 If you choose to work with the DNG format, be sure to tick the option Ignore sidecar ".xmp" files. That's what tells Camera Raw to store the adjustments in the DNG file.

6 Set the JPEG and TIFF Handling menus to Automatically open [file type]s with settings.

7 Click OK.

Camera Raw Preferences (Version 6.0.0.205)

General

Save image settings in: Sidecar ".xmp" files **3**

Apply sharpening to: Preview images only

Default Image Settings

☐ Apply auto tone adjustments
☑ Apply auto grayscale mix when converting to grayscale **4**
☐ Make defaults specific to camera serial number
☐ Make defaults specific to camera ISO setting

Camera Raw Cache

Maximum Size: 1.0 GB (Purge Cache)

(Select Location...) /Users/loubrz/Library/Caches/Adobe Camera Raw/

DNG File Handling

☑ Ignore sidecar ".xmp" files **5**

☐ Update embedded JPEG previews: Medium Size

JPEG and TIFF Handling

JPEG: Automatically open JPEGs with settings

TIFF: Automatically open TIFFs with settings **6**

HOT TIP: Every digital camera has a different raw format, which means that each time a manufacturer releases a new camera, Adobe has to release an update to Camera Raw that can read the new raw format. Windows and Mac OS also have to update some of their resources. As a result, there is often a slight lag between the time new cameras start shipping and when you can use their raw files with Camera Raw.

ALERT: Opening JPEG or TIFF files with Camera Raw doesn't turn them into raw files. You have the benefit of doing all of your initial edits in the same interface, but some features and capabilities of raw files are not available in the other file formats. Camera Raw can't process layered TIFF files.

Use the Adobe Camera Raw interface

Camera Raw is the functional equivalent of the Develop panel in Lightroom, but its interface has several differences. We'll look at some of the similarities and differences between the two in the remainder of this chapter.

When you double-click on a raw file in Bridge, it automatically opens in Camera Raw. To open JPEG or TIFF files in Camera Raw, click on the Open in Camera Raw icon in Bridge or Control-click/right-click on the thumbnail and select Open in Camera Raw... from the menu.

This section is a quick survey of the elements in the Camera Raw environment, listed clockwise from the upper left. Keyboard shortcuts for some of the controls are given below. Detailed discussion of many of these tools will come later in this chapter.

1 The toolbar includes rotate image buttons. Click the buttons or type L or R to rotate left or right, respectively.

2 The toggle preview (P) and full-screen (F) controls.

3 The histogram and info readout. The histogram includes clipping warnings for shadow/underexposure (U) and highlight/overexposure (O).

4 The adjustment panels are organised by a series of settings tabs that are labelled with icons. Hover the mouse pointer over a tab to see a tool tip describing it.

5 The Open Image, Cancel and Done buttons are self-explanatory.

6 Click the underlined text to open the Workflow Settings dialogue.

7 The Save Image... button and zoom control are at the bottom.

SEE ALSO: See the previous section, Set preferences for Camera Raw, for additional details on configuring Camera Raw.

ALERT: Camera Raw cannot read layered TIFF files. If JPEG and TIFF support are disabled in Camera Raw, it will not open JPEG or TIFF files, even when they contain settings.

Use the adjustment tabs in Camera Raw

Most of the work of Camera Raw is done with sliding controls that are grouped into tabbed panels. Hover the mouse pointer over a tab to see its name in a tool tip.

1 Basic: includes white balance, exposure, vibrancy.

2 Tone curves: Parametric and Point curves can be used together.

3 Detail: noise reduction and sharpening.

4 HSL/Grayscale: colour adjustments and conversion to black and white.

5 Split toning.

6 Lens correction: lens defringing and lens vignetting.

7 Effects: grain and post-crop vignetting.

8 Camera calibration: includes process and camera profiles.

9 Presets.

10 Snapshots.

HOT TIP: It's best to work your way through the tabs from left to right as you adjust your image since some tools (especially the tone curves) build on the settings from the Basic tab.

Use the White Balance tool

The White Balance and Tint controls in both Camera Raw and Lightroom work together to neutralise two aspects of light that produce colour casts in a photo. They shift the colours in the image so that the areas which are supposed to be a neutral grey come out that way and the rest of the colours fall into line.

To get the most neutral colour, you can shoot a special grey target for use with the White Balance tool. There may also be times when you want to intentionally push the white balance to create a more artistic result by making the image cooler (bluish) or warmer (orangeish), rather than neutral. Here are some approaches to using White Balance.

1. Try different presets in the White Balance menu. Notice that each preset changes the shape of the histogram and assigns different settings to the Temperature and Tint sliders. The options for white balance with JPEG files are more limited than with raw files: your choices are only As Shot, Auto or Custom.

2. Click on the White Balance tool in the upper left portion of the Camera Raw interface, then click on a grey target or click on an area in your image that should be neutral grey. The new white balance will be set.

3. If you don't like the result, try clicking somewhere else. Clicking on things that are warm-toned in real life will impart a cool tone to the image, while clicking on things that are cool-toned in real life will impart a warm tone to the image.

4. Once you establish a neutral white balance for your image, you can then intentionally warm it or cool it by shifting the white balance – you could set each image to 200K above its neutral white point, for example.

5. Try a mix of approaches. You can start with a preset, then move the Temperature slider. As you move the Temperature slider to the right, your image will take on a progressively more yellow-orange tone. If you move it to the left, the image will become increasingly blue.

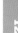

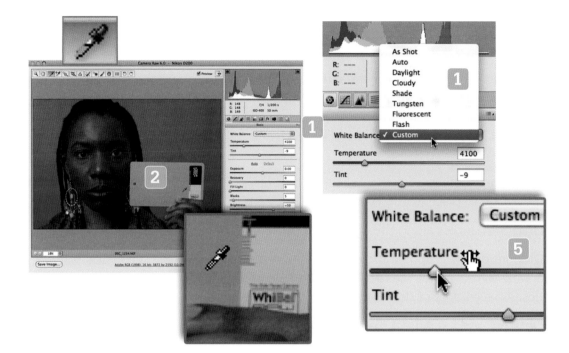

Crop or straighten an image in Lightroom

Lightroom combines what appear as separate Crop and Straighten tools in Camera Raw into one. This section will cover the differences in Lightroom and the two sections that follow will go into crop and straighten in slightly more detail.

1. Click the Crop Overlay icon or tap R to activate the tools. The Crop Overlay panel will appear.

2. To begin cropping, click the Aspect icon (it disappears from the panel) and drag in the image to place a crop rectangle.

3. Drag the handles along the edges and corners of the crop rectangle to resize it.

4. Drag inside the crop rectangle to reposition the cropped area. The image will appear to move, not the rectangle. The Rule of Thirds grid overlay will help you position elements of the image within the frame.

5. Optional: use the Aspect menu to select preset proportions for the crop rectangle.

6. Optional: click the lock icon to vary the proportions of the rectangle independently. Click it again to lock the proportions together.

7. To change the angle of the image, do any of the following:
 - click the Straighten tool icon (it disappears from the panel) and drag in the image to define a horizontal or vertical line, then, when you release the mouse button, the image will adjust
 - drag the angle slider to vary the angle
 - position the mouse pointer outside the crop rectangle. The cursor will change to a bent arrow shape. Drag the mouse up or down to rotate.

8. Click Close to finish cropping or straightening.

9. Click Reset on the Crop Overlay panel to remove cropping and straightening.

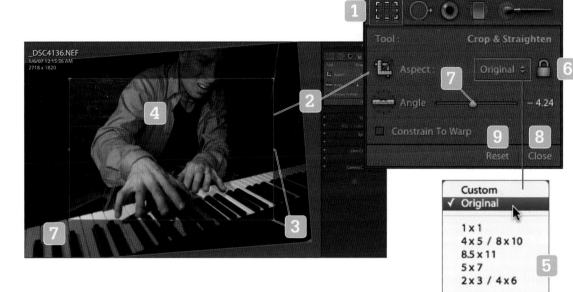

DID YOU KNOW?

Most digital SLRs produce images with the same proportions as 35mm film: 2 to 3. The most common aspect ratios in still cameras are 2 to 3, 3 to 4 and 1 to 1. The 16 to 9 aspect ratio is standard for HDTV and European digital television. However, there are other aspect ratios worth considering.

HOT TIP: If the overlay grid doesn't appear, set the Tool Overlay menu beneath the image to Always. Tap the letter O key to cycle through other composition overlays including Diagonals, Golden Section and the Fibonacci Spiral.

Crop an image or remove cropping in Camera Raw

Use cropping to reframe your image. Aside from free form (Normal mode) cropping, the Crop tool in Camera Raw has preset aspect ratios that match classic camera formats, plus you can specify your own custom shape. Cropping in Camera Raw is non-destructive, like all other Camera Raw adjustments.

1. Optional: choose Custom… from the menu and enter a proportion (such as 16 to 9) or select a preset proportion like 1 to 1.

2. Hold the mouse button down in the image area and drag out a rough selection. (Notice that Camera Raw has dimmed the part of the image outside the cropped area when you release the mouse button.)

3. Hold the mouse button down inside the cropped area and drag to reposition it.

4. To scale or rotate, position the mouse pointer so that the cursor changes to the appropriate shape and then drag. The cursor will change shape depending on whether it is directly over or slightly outside one of the handles.

5. Hit the Return key to commit the crop.

6. To remove cropping from an image, choose Clear Crop from the menu.

HOT TIP: If you change your mind about cropping and you haven't committed the cropped area, you can hit the Esc key to cancel.

SEE ALSO: If you crop in Photoshop, you can evaluate the composition with a 'rule of thirds' grid for attractive proportions. See the previous section.

Normal

1 to 1
2 to 3
3 to 4
4 to 5
5 to 7

16 to 9

Custom...

Clear Crop

Custom Crop

Crop: Ratio

16 to 9

OK

Cancel

DSC_0124.NEF

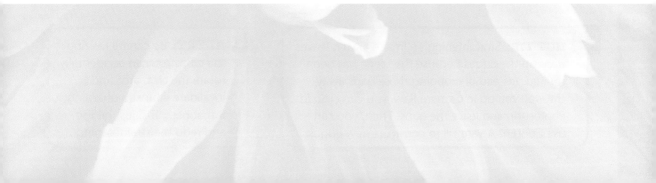

Straighten an image in Camera Raw

The Camera Raw Straighten tool is really an extension of the Crop tool. It allows you to define what is vertical or horizontal in your picture, then rotates and crops the image so that the sides are square. Like the Crop tool in Camera Raw, Straighten is reversible.

1 Drag a dotted line with the tool to indicate either the horizon line or a line that should be perfectly vertical.

2 The Crop tool will become active when you release the mouse button.

3 As with the Crop tool before, you can use the corner handles to resize the crop and you can drag the crop area.

4 Hit the Return key to accept the crop.

5 To remove straightening, choose Clear Crop from the Crop tool menu.

HOT TIP: Straightening an image always leaves gaps on the edges because the scene has been rotated. Instead of cropping those gaps away, the way you do in Camera Raw, you can crop in Photoshop and leave the gaps. Then, you can use Content-Aware Fill to construct new edges.

ALERT: Be careful resizing the crop. You can accidentally rotate the crop area and invalidate your straightening. If that happens, just hit Esc and redo the straightening.

Remove red-eye in Lightroom

Red-eye can be a common problem with on-camera flash, especially in dark rooms. The Red Eye Correction tool is very easy to use and an effective way to get rid of those troublesome eyes.

1. Zoom in to show the eyes up close. Use the Zoom slider on the toolbar and the Navigator panel to position the eyes.

2. Click the Red Eye Correction icon on the strip immediately below the Histogram.

3. Place the cursor at the centre of the eyes and drag downwards and outwards until the markers surround the pupil, then release the mouse button.

4. Unless the other eye appears considerably smaller, click the centre of the second eye to place a second red-eye removal without having to resize.

5. Optional: adjust the Pupil Size slider to remove any residual red.

6. Optional: change the setting of the Tool overlay menu on the toolbar beneath the image to hide the red-eye circles. Click to toggle the On/Off switch at the lower left corner of the Red Eye Correction panel and evaluate the red-eye reduction.

7. Optional: click Reset at the bottom of the panel to clear the corrections.

8. Click Close in the panel or Done on the toolbar to commit your adjustments.

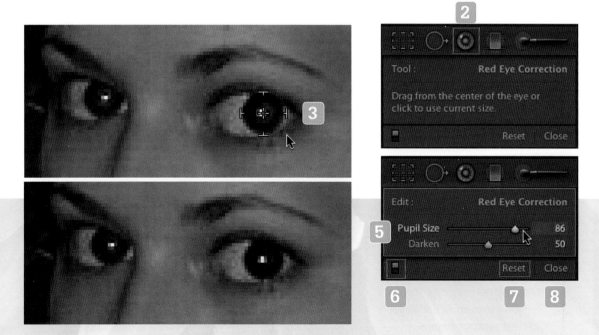

Remove spots in Lightroom

Lightroom removes spots by covering them with data copied from another part of the image. You encircle the area you want to repair and then specify where to get data to cover the spot with. You can specify whether to use the healing or cloning method for each spot that you remove. Cloning simply duplicates the source data to cover the target spot. Healing tries to blend the data into the area surrounding the spot you're covering. You can also vary the opacity (especially when cloning spots) to get a better match.

Before you begin, use the Zoom control on the toolbar and the Navigator panel to magnify the area you want to repair. Tap the Q key or click the Spot Removal icon between the Histogram and the Basic panel to activate the tool. Use the steps below to repair as many spots as you need.

1 Click on a spot that you want to remove (the target). A circle will cover the spot and a second circle will appear adjacent to it.

2 Optional: use the size slider or drag the edge of the circle (the mouse pointer will change to a double-headed arrow with a bar in the middle) and resize it to cover the spot.

3 Drag the second circle to the area of the image that you want to copy (the source). When you release the mouse button, an arrow will point from the source circle to the target circle.

4 Optional: drag either circle from the centre (the mouse pointer looks like a hand) to reposition it. You can also click on a circle and use the arrow keys for small movements.

5 Optional: select a Tool overlay option from the menu beneath the image window. This allows you to hide the circles and evaluate the repair more easily.

6 Optional: toggle the On/Off switch at the lower left edge of the tool controls to see how the repair is working.

HOT TIP: If you decide later that you don't like the way the spot repairs worked, you can always reactivate the spot removal tool and click Reset to clear all spot repairs.

? DID YOU KNOW?
The spot removal tool in Camera Raw works in a similar fashion to spot removal in Lightroom, but with a slightly different interface.

7 Optional: click a circle to select it. Click Clone or Heal to change the method of repair or hit Delete/Backspace to remove it.

8 Click Close at the bottom of the Spot Removal panel to complete the process.

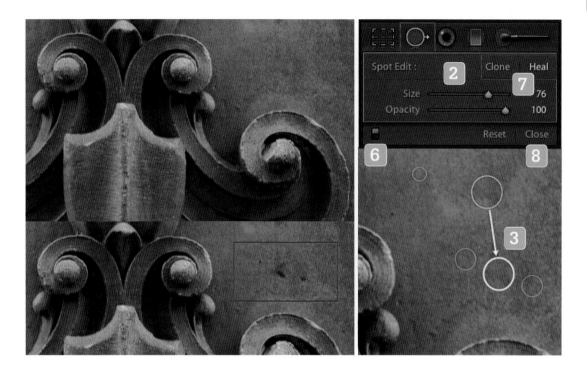

Adjust exposure, recovery, fill light and so on in Camera Raw and Lightroom

This set of controls can be found in the Tone section of the Basic panel in Lightroom and under the Basic tab in Camera Raw. They allow you to adjust the tonality of your image, and it's typically best to work from top to bottom with these controls when you make your first pass. As you move the sliders, notice how the histogram changes shape. You can use these controls with the clipping warnings – toggle them by clicking on them to show clipped shadows in blue and clipped highlights in red.

Raw files have a significant amount of latitude, allowing you to recover detail in nearly blown highlights and blocked shadows. Highlight recovery is not possible with JPEGs or TIFFs.

1. Move the Exposure slider to lighten or darken all tones in the image. At some point, parts of the image will look either too light or too dark.

2. If you have 'blown' highlights (pure white and missing detail), you may be able to restore detail with the Recovery slider. Move the slider to the right by degrees until you see the details appear. Notice that, at higher settings, some middle tones are also affected.

3. Use the Fill Light control to lighten details in the shadows. It can 'open up' shadow details that are 'blocked'.

4. The Blacks slider works somewhat differently from Fill Light and can add substance to a photo that doesn't have any pure blacks or it can reduce the heaviness of an image by lightening all of the dark elements.

HOT TIP: Toggle the Preview tick box on and off as you adjust the image to check your progress. It's not always easy to gauge when your adjustments have gone too far.

? DID YOU KNOW?

Clipping isn't always a bad thing. Sometimes the drama of a photo lies in the fact that part of it is plunged into complete blackness or there is a bright spot of pure white light in the midst of it. Let the indicators advise you, but not control you.

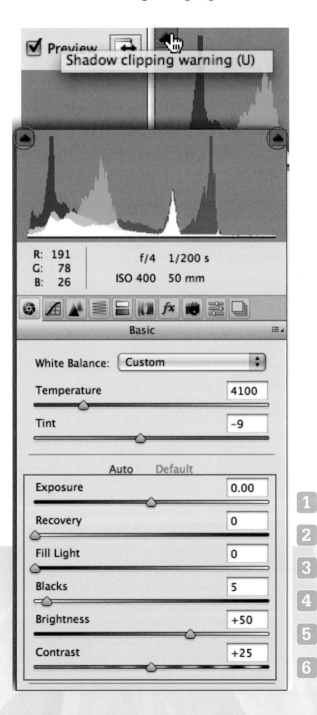

5 Use the Brightness slider to adjust the upper middle tones the most. It makes the overall image brighter, but does not shift the shadows and the brightest parts of the image as quickly as the Exposure slider.

6 Use the Contrast slider to increase or decrease the difference between light and dark values. Move the slider both left and right to gauge its effect.

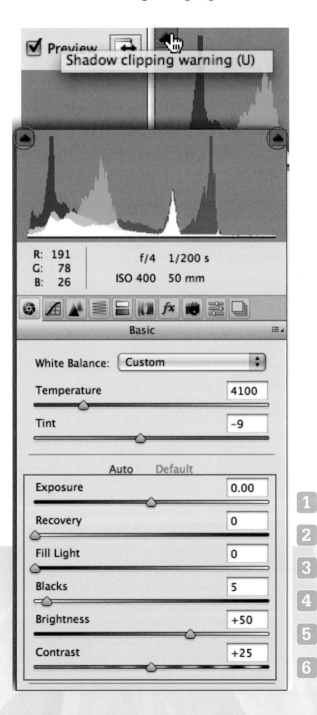

Use Noise Reduction in Camera Raw or Lightroom

The new Noise Reduction feature in Lightroom 3 and Camera Raw 6 works well and it is simple to use. Adobe has rewritten the feature for Camera Raw 6/Lightroom 3 and it is remarkably better at preserving colour and detail as it removes noise, compared to earlier versions.

Digital noise tends to be a problem when shooting at high ISO, and it is more pronounced on cameras with smaller sensor chips (such as APS or DX). It comes in two forms. Colour noise occurs as bright, coloured dots that appear in a random pattern, particularly in the shadows, and luminance noise consists of pixels that are too light or too dark compared to their neighbours. Noise becomes even more of a problem as you try to lighten dark images.

Click on the Detail panel in Lightroom or the Detail icon in Camera Raw to bring up the Sharpening and Noise Reduction controls.

1 Zoom in to at least 100% to see the effects of these controls clearly.

2 Use the Luminance slider to even out luminance noise.

3 The Luminance Detail and Luminance Contrast controls become available when you move the Luminance slider above zero. Use them to refine the image further.

4 Use the Color and Color Detail sliders to remove colour noise.

 HOT TIP: Even though there are sharpening controls in Lightroom and Camera Raw, sharpening is specific to the medium and the resolution you're making the image for. If you plan to work in Photoshop, you'll sharpen at the end of the editing process. Lightroom also has output-specific sharpening tools elsewhere. The sharpening controls are available here because sometimes a bit of preview sharpening can help during the adjustment process.

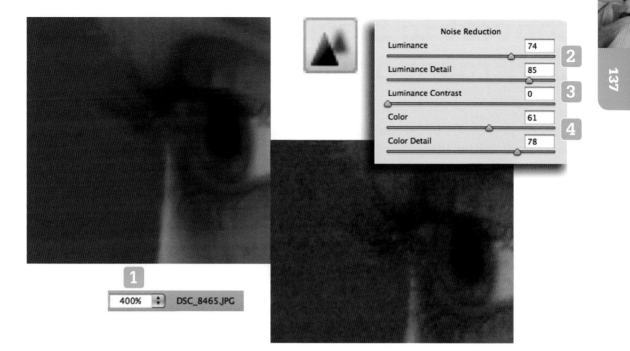

400% ⬍ DSC_8465.JPG

Noise Reduction

Luminance 74 ②

Luminance Detail 85 ③

Luminance Contrast 0

Color 61 ④

Color Detail 78

Convert to black and white in Lightroom or Camera Raw

Black and white conversion works by translating colours in your photo to different shades of grey. Sliders in the tool correspond to the principal colours of the rainbow (red, orange, yellow, green, blue, violet), plus aqua and magenta. The default mix can be good, but often you can make your black and white image sing by tweaking the tones that correspond to a particular colour – showing the reds as a darker grey and the yellows lighter, for example. Depending on the colours in your photo, some sliders may produce no effect, while others can dramatically shift the look of your image.

1. In **Lightroom**, click on Black & White in the Treatment section at the top of the Basic panel or on B&W at the top of the HSL/Color/B&W panel.

2. Scroll down to the HSL/Color/B&W panel to view the controls and click the disclosure triangle to expand the panel if you need to.

3. Use the individual sliders to lighten or darken the greys that correspond to that colour.

4. Optional: click Auto to use the automatic mix.

5. Optional: click the On/Off switch at the top left of the panel to toggle between the default greyscale mix and the slider settings.

6. Optional: click the target icon in the upper left corner of the dialogue box to activate the targeted adjustment tool. Drag up or down in the image to adjust the corresponding sliders.

7. Click Done on the toolbar to commit your changes.

8. In **Camera Raw**, click on the HSL/Grayscale tab.

HOT TIP: You can also get a black and white effect with the Hue/Saturation controls by moving the Saturation slider all the way to the left. However, that approach tends to produce very flat-looking black and white images.

9 Tick the box labelled Convert to Grayscale; the panel will display the Grayscale Mix controls.

10 Use the individual sliders to lighten or darken the greys that correspond to that colour.

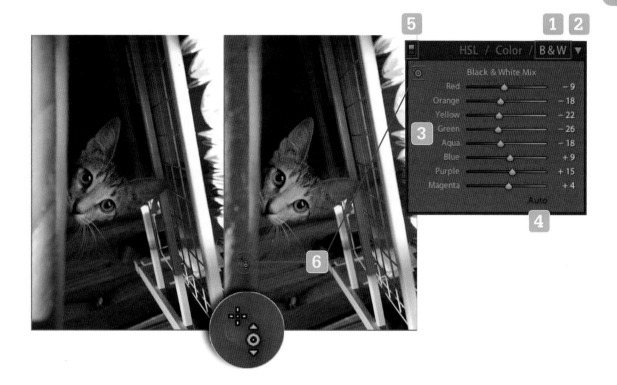

Add post-crop vignetting and simulate film grain

Digital noise is something that we try to eliminate, but film grain can be aesthetically pleasing. Photographers took advantage of the Lens Vignetting tool in previous versions of Camera Raw, but that had to be readjusted if you changed the cropping. Post-crop Vignetting automatically reapplies the vignette effect after you crop an image or remove the crop.

1 Click the Effects tab in Camera Raw or expand the Effects panel in Lightroom.

2 Zoom in to evaluate the grain effect.

3 Use the sliders to create your grain effect.

4 To evaluate the vignette, choose Fit in View from the Size menu or hit Command/Ctrl + 0 (zero) in Camera Raw. In Lightroom, tap the space bar or click FIT at the top of the Navigator panel.

HOT TIP: Midpoint doesn't have to do with location in the image; the vignette is always drawn from the centre. Midpoint has to do with the steepness of the transition in the vignette. A low value affects more of the image than a higher value.

5 Slide the amount to the left or right to darken or lighten respectively.

6 Choose a style from the menu to alter how the vignette affects colours and tones in the image.

7 Adjust Midpoint, Roundness, Feather and Highlights to alter the character of the vignette.

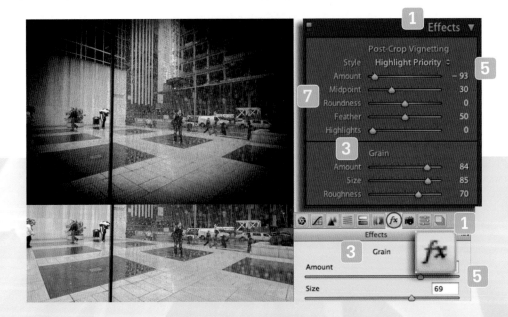

Make variations with virtual copies in Lightroom

Lightroom's catalogue database makes it possible to store different combinations of develop settings and adjustments as virtual copies, all stacked together with the original image. Virtual copies have a Copy Name field and a turned-up page icon at the lower left corner of the thumbnail. You can create as many virtual copies as you like. Once you have created a virtual copy, you can select it and switch to the Develop module to apply Develop settings to it. The illustration shows the original and two virtual copies with different settings applied. To create a virtual copy, follow the steps below.

1. To create a virtual copy, select one or more images in the Grid view.

2. Choose Photo, Create Virtual Copy from the menu bar.

3. Alternatively, Control-click/right-click on a photo and choose Create Virtual Copy from the menu that appears.

? DID YOU KNOW?
You can also make snapshots of different variations and save them inside your image as you edit.

Use Develop presets in Lightroom

You can save groups of Develop settings as presets, making it easy to recreate looks with the click of a button. Lightroom comes with a number of presets fashioned by Adobe. You can modify them and save the variations as your own or create presets from scratch. To apply a preset, select one or more images in the Grid view and click on the name of the preset in the Presets panel. The panel's presets are arranged in collapsible folders. Click the disclosure triangle to the left of the folder's name to expand or collapse it.

To create a new preset, do the following.

1 Adjust your image.

2 Click the plus sign (+) icon at the top of the Presets panel.

3 Enter a name and specify which folder it will be stored in.

4 Tick off the settings you wish to include in the preset.

5 Click Create.

Considering Photoshop

After seeing what you can do with Lightroom, you might be wondering why you would want to edit your images with Photoshop. The simple answer is that you can take your images a lot farther in Photoshop than you can with virtually any other image editing application available.

Unlike parameter-based editors such as Picasa and Lightroom, Photoshop's tools are designed to operate at the level of pixels and layers, and involve a more complex set of concepts. Mastering those tools requires substantially more time and effort than it takes to be proficient with parameter-based editors, but Photoshop rewards your efforts by allowing you far higher degrees of precision and flexibility.

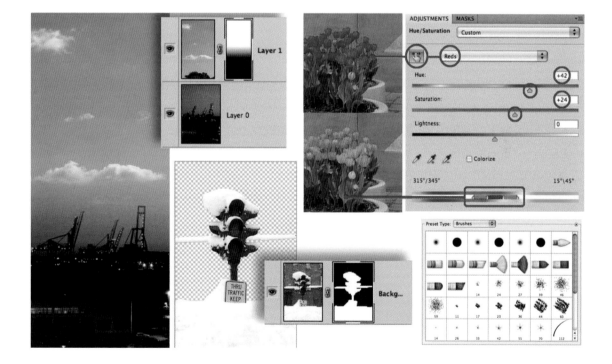

That doesn't mean you should edit every image in Photoshop. You can opt to move an image into Photoshop only when you want to take advantage of its distinct capabilities. Several are listed below.

- Replace skies and backgrounds or remove unwanted elements from images.
- Merge multiple photos into panoramas, composites, and HDR (High Dynamic Range) images.
- Combine text and images to create cards, scrapbook pages, and complex illustrations.
- Retouch with advanced cloning, healing, patch, and fill tools.
- Use painting tools to apply colour and texture.
- Convert photos into paintings with the Mixer Brush: use photographs as if they're wet paint, mixing colour and texture from the photo itself.
- Use a graphics tablet to control Bristle Tips and other Photoshop tools via stylus pressure and tilt.
- Reshape elements with Puppet Warp, Free Transform, and Liquify.
- Easily mix colour and black and white elements in the same image
- Apply a wider range of tonal and colour adjustment tools.
- Use Photoshop filters for a range of creative effects not available in other editors.
- Precisely apply effects to selected parts of the image with masks. (Much more selectively than with the Adjustment Brush in Lightroom.)
- Use Soft-Proofing for better printing and colour conversion results.
- Print with preview and greater colour control.

? DID YOU KNOW?

Proper coverage of Photoshop's features and operation requires an entire book. *Photoshop CS5 in Simple Steps* (Prentice Hall) covers Photoshop, Camera Raw and Adobe Bridge in great detail.

Round-trip editing: edit files in both Lightroom and Photoshop

Lightroom can adjust raw, JPEG, TIFF and PSD (Photoshop) files. Round-trip editing means that you can edit files in Lightroom, refine them in Photoshop, then readjust the resulting Photoshop file in Lightroom. You can use the External Editing page of the Lightroom preferences to control how Lightroom hands off images to Photoshop.

If you want to edit a raw file in Photoshop, it simply opens when you select the Edit In Photoshop command in Lightroom. If you opt to edit JPEG, TIFF or PSD images, you will have a choice to make first. You can edit a copy with or without Lightroom adjustments applied or you can edit the original. If you choose to edit a copy of a layered Photoshop file with adjustments applied, it will open in Photoshop as a flattened file. Lightroom will catalogue the new Photoshop file and stack it with the original, as long as you don't change its name or location when you first save it.

1. Optional: select Lightroom, Preferences (in Windows, select Edit, Preferences) from the menu bar to open the Preferences dialogue box. Click External Editing in the navigation bar at the top of the dialogue box to edit the preferences for Photoshop or specify preferences for an alternative external editor, such as Photoshop Elements or PaintShop Pro.

2. To open a file in Photoshop, Control-click/right-click in the image window to display a menu and choose Edit In, Edit in Adobe Photoshop CS5... or Choose Photo, Edit In, Edit Photo with Adobe Photoshop CS5... from the menu bar.

3. If prompted, select whether to edit a copy or the original.

4. Edit in Photoshop and choose File, Save when you've completed your edits. By default, the new file will be saved with –Edit appended to the end of its name.

HOT TIP: If you open a Photoshop file from within Photoshop or via your computer's operating system, any adjustments made in Lightroom will be ignored. Lightroom can edit layered Photoshop files, but not layered TIFF files.

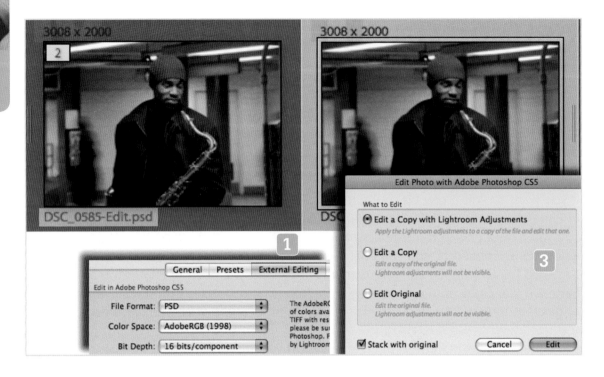

5 Prepare images for sharing

Introduction

Preparing images for sharing comes down to packaging them in some way. If you're dealing with sending a single image to someone via e-mail, it's often useful to resample it from its original 10-megapixel or more size to something that fits better on a computer screen and to convert its colour space to sRGB – the standard for Web viewing. Another concern is sharpening an image for viewing or printing. If you need to send an image to a service bureau for high-quality printing, you might need to save it as a high-resolution TIFF file. Beyond one-off images, you might want to place multiple images into PDF documents or even a slide show with an audio track.

Export files from Lightroom

You can export files from the Library module of Lightroom in JPEG, TIFF, PSD (Photoshop), DNG and the original format of the selected file(s). Exported files can be written to your hard drive or directly to a CD/DVD. The Export dialogue box has several sections that can be expanded or collapsed by clicking on the disclosure triangle for the section. To begin the export process, select one or more photos in Grid view, then click the button labelled Export... in the lower left corner of the window.

1 If you are exporting to a hard drive, use the Export Location section to specify where your files will be saved.

2 Optional: use the File Naming section to rename the file as needed.

3 Use the File Settings section to specify the file format, colour space and bit depth. Additional options will appear based on your selection from the Format menu.

- JPEG is only 8-bit. Select a quality level. A setting of 90 produces a file that is roughly half to a third the size of the 100 setting and it will be difficult to see the difference.

- TIFF has the option to use lossless ZIP compression. Files saved with this option are smaller, but take more time to open and save. ZIP compression will not degrade your image the way that JPEG compression does.

- If you save in DNG format, you'll have the option to choose your compatibility level, what size preview to embed and whether or not to embed the original raw file.

4 Optional: in the Image Sizing section, tick the box marked Resize to fit and specify the dimensions and resolution to use.

5 Optional: in the Output Sharpening section, tick the box marked Sharpen For and select the media type and amount of sharpening from the menus.

6 Optional: in the Metadata section, tick Minimize Embedded Metadata to prevent keywords, camera data and so on from being included in the exported file.

7 Optional: use Watermarking to place an overlay containing your copyright notice and so on on the photo.

8 Optional: use the Post-Processing section to specify how the files will be handled after they have been exported. With this feature you can set Lightroom to start a new e-mail message and attach the exported files.

9 Optional: click Add in the lower left corner of the dialogue box to save your export settings as a preset.

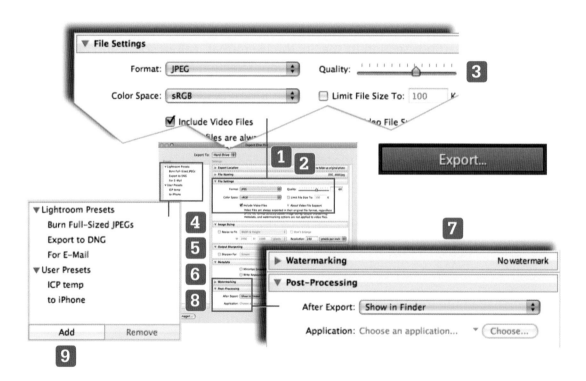

Export files from Picasa

Picasa's export allows you to create JPEGs of any size, set image quality and add a simple watermark.

1 Select one or more images in the library.

2 Click the Export icon at the bottom of the window.

3 Enter a path for the folder to hold the exported photo(s) or click Browse to select.

4 Specify image size and quality.

5 Optional: tick the Add watermark box and enter your watermark text (such as your copyright notice) into the box. Your watermark will then appear in the lower right corner of your image.

6 Click Export.

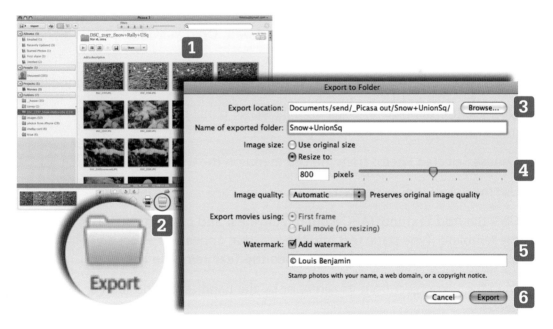

HOT TIP: To type the copyright symbol on a Mac, use Option + G; in Windows, hold down the Alt key, type 0169 on the numeric keypad, then release the Alt key.

Set up a slide show in Lightroom

The tools for creating slide shows in Lightroom are pretty robust. First, select and sequence your images.

1 In the Library module Grid view, select images to include in your slide show, then switch to the Slideshow module.

2 To allow ordering, press the mouse button down on the plus sign (+) at the top of the Collections panel to show a menu and select Create Slideshow...

3 In the dialogue box that appears, tick the box labelled Include selected photos and name and save the set. Placing the files in a set allows you to resequence them.

4 The set starts out with all photos selected appearing on the Filmstrip. Use Command/Ctrl + D to deselect the images.

5 Click a thumbnail on the Filmstrip to preview it. Drag individual photos along the Filmstrip to change their order.

6 Next, select an initial format for your slide show and modify it with the toolbar.

7 Now use the Template Browser and Navigator panel on the left side of the window to preview and select a template.

8 Choose Selected Photos from the Use menu on the toolbar.

9 Use the Rotate tool as needed.

10 Click the Add Text tool (ABC icon) to activate it and place metadata or static text in the template. Type static text into the box that appears or select an item from the menu to add a metadata preset or open the Text Template Editor.

11 Drag the text object from its centre or by the handles to reposition or resize it as needed.

12 Finally, use the panels on the right side (Options, Layout, Overlays, Backdrop, Titles, and Playback) to refine your slides.

13 Optional: use the Titles panel to add intro and ending slides.

14 The Playback controls only apply if you save your slide show as a video. Tick the box labelled Soundtrack and click Select Music to add an audio track. Once the soundtrack has been selected, you have the option to click the button Fit to Music to time the slides so they fit the length of the audio.

15 When you're happy with the design of your slide show, you can click the plus (+) icon on the Template Browser on the left to save the setup as a template for future use.

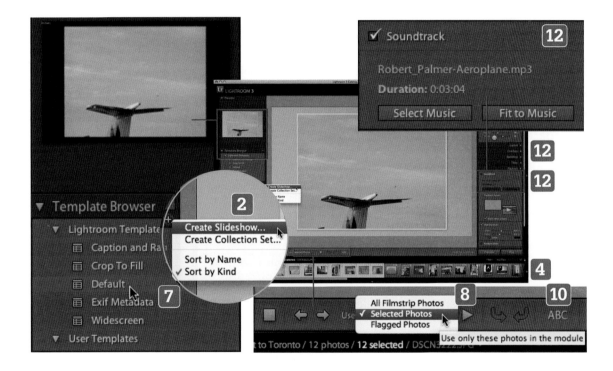

HOT TIP: If you want to use music from your iTunes library, Control-click/right-click on a song and choose Show in Finder/ Show in Windows Explorer from the menu. From there, you can copy the file to another location to make it easier to work with.

Export a slide show from Lightroom

Lightroom can save your slide show as an MP4 movie file or as a more limited PDF document compatible with Adobe Acrobat and Apple's Preview.

When you make a PDF slide show, the PDF player sets the playback options of the slides. Slides are automatically converted to sRGB when the slide show is exported. They have no soundtrack and no random order option.

1 Click Export Slideshow to PDF. A Save As dialogue box appears.

2 Name your slide show and specify where it will be saved.

3 Use the Quality setting to manage JPEG compression. A lower quality creates a smaller file.

4 Enter a Width and Height in the boxes or use the Common sizes menu to set the space that the slides will be sized to fit.

5 Optional: tick the box Automatically show full screen.

6 Click Export to create the slide show.

7 To save your slide show as a video file, click the Export Slideshow to Video button. A Save As dialogue box will appear.

8 Use the Video Preset menu to determine pixel size and frame rate.

9 Click Export to generate your file.

 HOT TIP: Once you have set up a slide show, you can play it in Lightroom without exporting. Click the Play button on the toolbar of the Slideshow module to start the show. You can also use the Play button on the toolbar of the Library module. The currently selected photos will be shown using whatever slide show template is current.

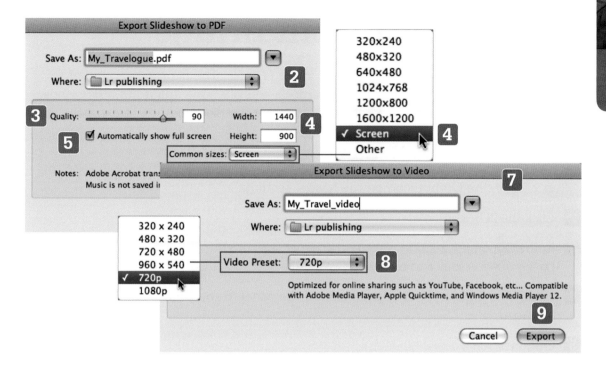

Save to PDF from Bridge

Bridge can combine a selection of images into a PDF file. The file can even be set so that, on opening, it expands to full-screen mode and plays the images as a slide show. Use the triangles on the left edge of each section of the dialogue box to expand and collapse them.

1 Select Output from the Workspace Switcher at the top right section of the window or click on the Output icon on the header section.

2 Click the PDF icon.

3 In the Document section, specify the paper size, orientation, image quality, background colour and optional passwords.

4 Use the controls in the Layout section of the panel to specify how the images will be arranged.

5 Optional:

- if you want to review the PDF as soon as you save it, make sure that the box marked View PDF After Save is ticked.
- add the filename and page numbering in the Overlays section
- add headers and footers
- set automatic Playback options including Full Screen Mode and transitions
- add a watermark.

6 Optional: click the Save Template icon to add the settings to the Template menu.

7 Click Refresh Preview to see what the first page will look like. The output preview appears on a tab in the centre section along with the Preview panel.

8 Click Save... and use the controls in the Save As dialogue box to name your PDF and specify where it will be saved.

9 Click Save.

OUTPUT

PDF **2** | WEB GALLERY

Template: Custom ▼ **6**

Refresh Preview **7**

▼ Document

Page Preset: International Paper ▼

Size: A4 ▼

Width: 21 cm ▼

Height: 29.7 **3**

Quality: 72 ppi ▼

Quality: [slider] 70

Background: White ▼

☐ Open Password:

☐ Permissions Password:

☐ Disable Printing

▼ Layout

Image Placement: Across First (By Row) ▼

Columns: 2 Top: 0.43 cm

Rows: 2 Bottom: 0.43 cm **4**

Horizontal: 0.64 cm Left: 0.43 cm

Vertical: 0.64 cm Right: 0.43 cm

☐ Use Auto-Spacing

☐ Rotate for Best Fit

☐ Repeat One Photo per Page

▶ Overlays
▶ Header
▶ Footer **5**
▶ Playback
▶ Watermark

☐ View PDF After Save Save...

Create a movie in Picasa

Picasa automatically stores slide shows as movies in a folder nested inside the folder containing your Picasa application. Click the Movie icon in the lower right portion of the Picasa window to start building a slide show.

1 On the Movie tab, add an audio track and set options (truncate, fit photos into audio, loop images).

2 Set the Transition Style, Slide Duration and Overlap.

3 Set the dimensions of the movie, such as 720p. Optional: use the tick boxes to specify captions and whether or not images are cropped to fit the frame.

4 On the Slide tab, specify the font, size, text and background colours and style of the slide text.

5 Choose a style template. For example, the Typewriter template types out the text one letter at a time.

6 Options at the bottom of the work area include:

- use the Add a new text slide button as needed
- click a slide on the Filmstrip at the bottom of the display area to select it
- click the red X button to remove the selected slide
- drag slides on the Filmstrip to resequence them
- press the green Play button to run a preview.

7 Next, generate your movie and finish up. First, click Create Movie to generate and store your movie.

8 Once your movie has been created, you can click Back to Library to return to the home screen.

9 Click the X on the Movie Maker tab to close it or click on the Library tab to return to the Library module without closing down the Movie Maker.

10 In the Library, click on Movies in the Projects section to show your saved movies. Click on the Folder icon at the top of the section to open the folder in Finder or Windows Explorer.

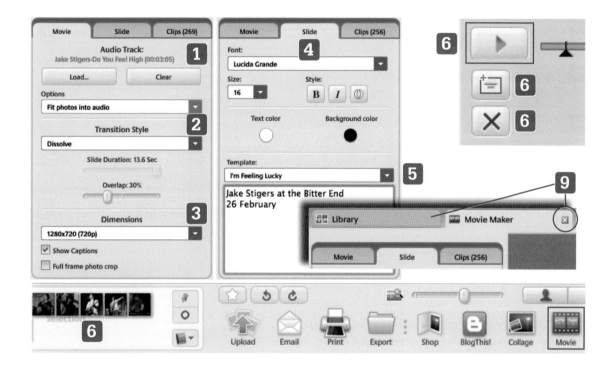

Resample in Photoshop using Image Size

The Image Size dialogue box is the main tool for changing the size of files, whether you are resampling or not.

1 Select Image, Image Size… from the menu bar to open the dialogue box.

2 Make sure that the boxes labelled Constrain Proportions and Resample Image are ticked.

3 For the Web, enter a width or height in pixels in the Pixel Dimensions area. The other dimension will be calculated for you.

4 When you are making the image smaller, use either Bicubic Sharper or Bicubic.

5 For printing, you may not need to resample. Check the resolution first: untick the Resample Image box and enter the dimensions you want to print in the Document Size area.

6 If the resolution goes well below 150 dpi, tick the Resample Image box and enter the resolution you wish to use (240 ppi is a good resolution to use for most inkjet printers.)

7 If you are making the image larger, use either Bicubic Smoother or Bicubic.

8 Click OK when you have established dimensions and resolution.

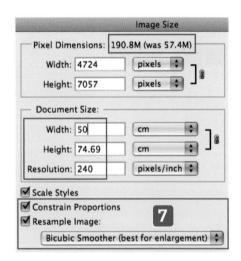

Image Size

Pixel Dimensions: 4.01M (was 57.4M) **3**

Width: 685 pixels
Height: 1024 pixels

Document Size: **5**

Width: 7.25 cm
Height: 10.84 cm
Resolution: 240 pixels/inch **6**

☑ Scale Styles
☑ Constrain Proportions **2**
☑ Resample Image: **5** **4**
Bicubic Sharper (best for reduction)

Image Size

Pixel Dimensions: 190.8M (was 57.4M)

Width: 4724 pixels
Height: 7057 pixels

Document Size:

Width: 50 cm
Height: 74.69 cm
Resolution: 240 pixels/inch

☑ Scale Styles
☑ Constrain Proportions
☑ Resample Image: **7**
Bicubic Smoother (best for enlargement)

HOT TIP: When printing, there are three magic dpi values to aim for. These values are the easiest resolutions for your printer software to work with. If you are printing to an inkjet or giclée printer, 240 dpi prints very well, while 360 dpi is *theoretically* better, but you will be hard pressed to tell the difference. Laser printers and digital C printers typically work best with 300 dpi output.

Use Smart Sharpen in Photoshop

The biggest problem with sharpening is that many people overdo it. One key to using it well is to sharpen at the size the image will be viewed. Resample a copy of your image to Web size or print size as needed, then view it at actual size as you sharpen. The technique outlined below makes it easy to apply sharpening effectively.

1 Begin by stamping a layer at the top of your layer stack to apply sharpening to. Click on the layer to select it.

2 Use the zoom technique to view your image at output size.

3 Hit the tab key to temporarily hide the panels and use the Hand tool, Bird's Eye View and so on to show an area that you want to sharpen, like the eyes, hair or something with important texture.

4 From the menu bar, select Filter, Sharpen, Smart Sharpen... The Smart Sharpen dialogue box will appear. Position it so that you can see your image *and* the dialogue controls.

5 In the dialogue box, be sure the Remove option is set to Lens Blur and leave More Accurate unticked.

6 Move the Amount slider all the way to the right, so that the amount reads 500%. Your image may look pretty bad at this point; that's fine.

7 Move the Radius slider all the way to the left – 0.1 pixels.

8 Now, slowly increase the Radius by sliding it a small amount at a time to the right until your image begins to look brittle. This is your sharpening radius.

9 Move the Amount slider to the left until the brittle quality just disappears.

10 Click to toggle the Preview box a few times, toggling the effect to evaluate how the sharpening is working. Readjust as needed.

11 Click the OK button to apply the effect and hit the tab key to restore the panels.

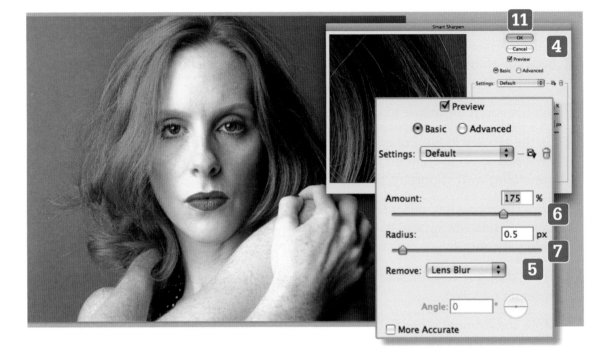

HOT TIP: Use the Opacity slider on your Sharpening layer to reduce the overall effect.

ALERT: Be careful about sharpening skin. It brings out pores and texture. You can use a layer mask to hide the sharpening on skin, though – use the Color Range command to assist in selecting the skin as you create the mask.

Create Web and e-mail images in sRGB

When you're editing images, especially in anticipation of making your own prints, large colour spaces like Adobe RGB and ProPhoto RGB give you room to manoeuvre, but when your images go out into the world of the Web and e-mail, many of the devices you'll send your photos to will only understand sRGB.

Photos rendered in the other colour spaces look wrong whenever the device you're sending the photo to effectively assumes that your image is in sRGB. Simply including a colour profile only helps in some cases; some Web browsers do not do colour management and others have it turned off by default. There are a number of places where you can convert your image to sRGB while saving or exporting, depending on the software you are using. There is an important caveat to converting between colour spaces. Because it is a destructive edit that discards and alters colours in your photo, you should be careful not to degrade your master copy.

1 In **Lightroom**, the dialogue box that appears when you click the Export... button has a menu labelled Color Space in the File Settings section. Choose sRGB from the menu.

2 In **Photoshop**, you can use the command Edit, Convert to Profile... to convert to sRGB.

3 The File, Save for Web & Devices... command brings up a dialogue box that has a tick box labelled Convert to sRGB.

ALERT: If you convert the colour space of one of your master files, be sure to use File, Save As... to save the converted file as a new version or step back in the History panel to undo the colour space conversion. Simply converting back to the previous colour space will not restore any colours that were lost in the first conversion.

Save for Web & Devices is designed for low-resolution images. If you try to use it with images that are too large, you'll get a message telling you that you may experience out of memory errors and slow performance. If that happens, click No, resample your image to the dimensions you need for the Web, then redo the Save for Web & Devices.

Save as JPEG from Photoshop

There are several ways to create JPEG files in Photoshop. The most direct way is via the File, Save As dialogue box. When you save JPEGs in this manner, you can save them at very high resolution.

There are a few considerations when saving JPEG files. The first is image quality. The biggest problem with the JPEG format is its characteristic compression artefacts. Be sure to inspect the preview carefully to avoid these issues. JPEG compression can make your files very small by degrading them drastically. Higher-quality images take up more disk space but, even at the highest quality level, lots of data have been discarded. In most cases, JPEG files are going to be used as e-mail attachments or on websites and shown on computer screens, which means you'll typically want to convert the colour profile to sRGB before you make your JPEG. You'll often want to resample the image to a size that fits better on most screens, too (see Resample in Photoshop using Image Size earlier in this chapter).

To save as a JPEG, select File, Save As... from the menu and specify a name and location, as with saving PSD files. Then do the following:

1 Select JPEG from the Format menu.

2 Be sure that Embed Color Profile is ticked.

3 Click Save. The JPEG Options dialogue box will appear.

4 Set the image quality. Toggle the Preview tick box to see how your settings are affecting the image.

5 Set the Format Options as you like. Progressive files look different as they load.

6 Click OK.

> ▶ **SEE ALSO:** Using File, Save As... to create a JPEG adds a custom icon consisting of a miniature of the image, which slightly increases the file size. If you are saving a file specifically for the Web, the Save for Web & Devices command (see next in this chapter) does not add the icon.

HOT TIP: If you are familiar with
earlier versions of Photoshop, you
used to have to explicitly convert
your 16-bit image to 8-bit mode
before you could save a JPEG. In
CS5, you no longer have to.

Use Save for Web & Devices in Photoshop

This tool allows you to create images for Web pages, e-mail attachments, phones and so on and save them in any of the main formats that are used on the Web, including JPEG and GIF. The 2-Up preview allows you to test your settings before saving and see what the file size and download time will be.

To use the feature, select File, Save for Web & Devices... from the menu bar. A dialogue box will appear, then do the following.

1 Click the 2-Up tab.

2 Choose JPEG from the file format menu or select an item from the Preset menu.

3 Tick both Embed Color Profile and Convert to sRGB.

4 Select a level from the Compression Quality menu, enter a number into the Quality field or select Optimize to File Size... from the Optimize menu and enter a size.

5 Optional: apply blur to reduce artefacts, Tick Progressive and/or Optimzed as you like.

6 Optional: select the amount of metadata you want to include.

7 Click Save.

8 Enter a name and select a location to save your file to.

9 Select Images Only and Default Settings from the Format and Settings menus at the bottom of the dialogue box.

10 Click Save.

> **ALERT:** Save for Web & Devices was designed for preparing smallish images for the Web, so you'll get a warning if the file you want to process is too large. If you need to make high-resolution JPEGs, GIFs and so on, use File, Save As... You can prepare images for this tool with the Fit Image or Image Size command.

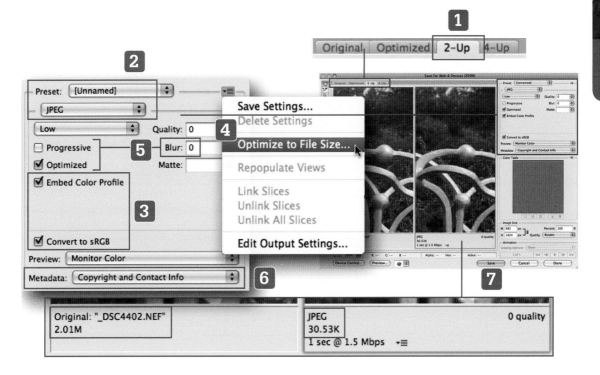

Original: "_DSC4402.NEF"
2.01M

JPEG
30.53K
1 sec @ 1.5 Mbps

0 quality

HOT TIP: Zoom in or out to evaluate the results as you're adjusting your settings. Zooming in to 200% or more will show JPEG artefacts more clearly, but generally you want to evaluate the image at 100%, since that's how other people are most likely to view it.

6 Make prints for sharing

Introduction

With the ease of sharing images on the Web, printmaking is sometimes overlooked. However, one major advantage of prints is that you can share photos in places where computers or hand-held devices don't cut it. Prints give you a kind of control that you don't have when you share things on the Web or by e-mail. While printing has its own challenges when it comes to getting the colours right, you get to determine the quality of the print and the colours that people see, while you can't control the resolution or colour performance of someone else's screen when they view your photo on the Web.

The capabilities of your printer, its drivers and your system software all enter into the equation when you print. As a result, this chapter will be a bit more general than the others in this book. The screenshots may not match what you see on your screen, but the principles being discussed will still apply. The aim is to give you enough information to get better prints and find out what you need to learn more about to get the best possible results.

Prepare for printing

Making prints is one of the easiest ways to share images and, almost surprisingly, inexpensive home printers can often make better prints than you can get commercially. The trick is in knowing how to finesse the best performance out of your printer. Good paper makes a big difference. It's a good idea to get the best paper you can for the kind of print you want to make. Keep in mind that not all papers work on all printers and some printers have very specific paper requirements.

- Glossy paper makes images appear to have richer colour and contrast than matt paper. They offer the widest colour gamut and glossy prints compare well to what you see on the screen.
- Semi-gloss and lustre papers are slightly less shiny and often a little less smooth than glossy paper. They still exhibit rich colour and contrast.
- Matt and watercolour papers are great for making prints that are more artistic. Watercolour paper is particularly known for its texture, which imparts a painterly quality to your prints. Matt prints do not have the 'pop' of more glossy papers.

After choosing your paper, your next decision is whether to have the printer manage colour or let your image-editing software do so. If you choose printer colour management, check your printer's options. If you print an Adobe RGB image with sRGB colour management, the colours will come out wrong. Some printers can colour-manage sRGB or Adobe RGB images, but if your printer only supports sRGB, you can temporarily convert your image to sRGB (use Edit, Convert to Profile in Photoshop, for example) and then print with the option to have the printer manage colours from there. Just be careful not to save and replace your master file after you convert it to sRGB.

When your image-editing software manages colours, it's important to be able to turn off the *printer's* colour management or your colours will come out wrong. You'll also need to select a colour profile that matches your printer and paper – the better your profile, the better the print. With poor colour profiles, you may find that you get better results with the printer managing the colours. You can often download updated printer

profiles from the websites of paper and printer vendors. You store them in a particular folder on your computer.

- **Mac OS X**: /Library/ColorSync/Profiles or
- /Users/<your username>/Library/ColorSync/Profiles

- **Windows XP or Vista**: \Windows\system32\spool\drivers\color
- (use the Color Management control panel in **Windows 7**).

Whenever you print, you'll need to choose either Perceptual or Relative Colorimetric as a rendering intent. The differences between the two are subtle, so it's best to do test prints with each setting when you want the best possible print. Even in the best cases, your print is not going to perfectly match what you see onscreen. In the next section we will discuss some ways to get the best possible match between your screen and the print.

HOT TIP: Sometimes, you'll want to apply sharpening to your print. You can do that on the fly in Lightroom. In Photoshop, you can create a version of your file at the resolution you want to print, view it at print size, and use Smart Sharpen for precise results. See Chapter 5 for details on Smart Sharpen.

Set up your display for the best results

If you plan to make lots of prints, you're likely to be concerned with how well they match what you see onscreen. Beyond colour accuracy, a common complaint is that prints can look much darker than what you see onscreen. You can use a profiling tool to address both of these issues. The tool will build a colour profile for your screen so that the colours you see are more accurate. It can also help you turn down the brightness of your screen to a target level. The factory setting for most screens is about three to four times brighter than the ideal for editing photos and printing, but they're set that way because the brighter screens look great for movies and video games. As part of the calibration process, the profiling tool will guide you through setting the brightness to the desired level.

You should also operate your screen in somewhat dimmed room light that does not overpower it. No direct light should hit the display – you shouldn't see reflections in its surface. Some screens have an ambient light sensor that tries to automatically adjust the brightness of your screen. You should turn this feature off.

Some high-performance displays come bundled with a calibration tool, but otherwise you can buy one. Simple 'puck'-style profiling tools, such as the X-Rite i1 Display and the Colorvision Spyder are relatively inexpensive. The X-Rite ColorMunki Photo is more advanced and can profile displays, printers and even digital projectors. We'll use it to walk through a typical profiling process. Depending on the tool you use, there will be some differences in the process, but the principles will be the same.

1 Launch the ColorMunki software.

2 Click Profile My Display.

3 Select the display you want to profile and click Next.

4 Set the following preferences, then click Next:

- display profiling mode: Advanced

HOT TIP: Displays' colour performance can change over time, so it's a good idea to reprofile your monitor from time to time.

- target level for the luminance value: 100 (you can select a higher value if matching prints is not important)
- Target White Point for display: Native

5 Calibrate the device and click Next.

6 Position the device on the screen and click Next.

7 Adjust the brightness when prompted and then click Next.

8 Click Save when prompted.

9 Set the Remind me option as you like and click Next.

10 Review Before and After, then click Next to finish.

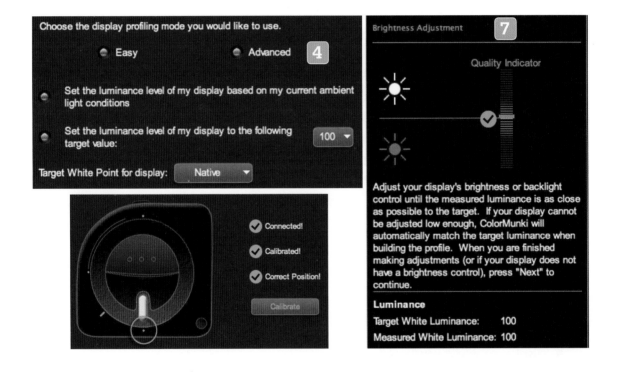

ALERT: You need a measurement device to produce accurate display profiles. Apple's system software has a Calibrate button on the Displays panel. Clicking it opens the Display Calibrator Assistant, which is supposed to help you 'calibrate' your display by eye. Adobe Gamma is a similar software assistant for Windows machines. These tools produce unreliable results that can be worse than no calibration at all!

Resize for printing in Photoshop

Resizing changes the size of your prints by making the printed dots larger or smaller instead of resampling the image. Unlike resampling, resizing does not alter the pixels in your image. When you print, you typically want your image to fall somewhere in the range of 240 ppi or higher for the best quality. With a 10-megapixel camera, that means that you can print up to about 27 × 41 cm without having to resample.

1 Choose Image, Image Size... from the menu bar. The Image Size dialogue box will appear.

> ▶ **SEE ALSO:** Chapter 5 discusses resampling and sharpening.

2 Make sure the box marked Resample Image near the bottom of the box is not ticked.

3 Enter a width or a height that best fits the paper you will be printing on.

4 Note the resolution. If the number falls well below 150 pixels/inch, you should consider resampling.

5 Click OK.

6 If you plan to regularly print at this size, save your file and these dimensions will be stored in the file.

Image Size **1**			Image Size		
Pixel Dimensions: 17.2M			Pixel Dimensions: 17.2M		
Width: 3008	pixels		Width: 3008	pixels	
Height: 2000	pixels		Height: 2000	pixels	
Document Size:			**Document Size:**		
Width: 10.027	inches	**3**	Width: 12.533	inches	
Height: 6.667	inches		Height: 8.333	inches	
Resolution: 300	pixels/inch	**4**	Resolution: 240	pixels/inch	
☑ Scale Styles			☑ Scale Styles		
☑ Constrain Proportions			☑ Constrain Proportions		
☐ Resample Image: **2**			☐ Resample Image:		
Bicubic (best for smooth gradients)			Bicubic (best for smooth gradients)		

? DID YOU KNOW?

A resolution of 240 dpi is a good one to target because it's a good fit with the resolution of most inkjet printers. Lower resolution means bigger dots. Once the dots get to somewhere around 100 dpi, they become visible at arm's length. That's when it's time to consider resampling to increase the ppi in the image. We use ppi to describe the pixels/inch on a screen and dpi to describe the dots/inch of a printer, so the two terms are analogous.

Print in Photoshop with Photoshop managing the colours

This page presents a summary of the entire printing process in Photoshop.

When Photoshop manages colours, it translates the colours in your image into the colour space of the printer profile. With an accurate printer profile, Photoshop can produce highly accurate colour prints.

1 Select File, Print… from the menu bar and the Print dialogue box will appear.

2 Select the printer.

3 Send 16-bit data when available.

4 Edit and save the print settings: this uses your printer driver's dialogue.

5 Set the page layout parameters.

6 Set the colour management parameters.

7 Check to see that your paper is properly loaded.

8 Click Print.

> **SEE ALSO:** The next four examples go into greater detail about the items summarised here.

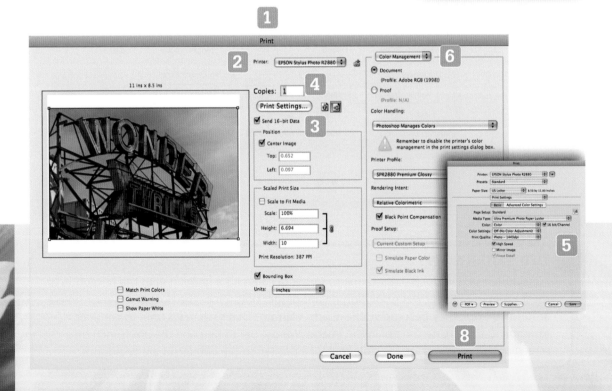

Edit and save Print Settings

The Print Settings dialogue box on the Mac is different from the equivalent dialogue box in Windows.

Photoshop stores the specified printer in the document along with its print settings. Click the Print Settings button to open the printer driver dialogue box. Because Photoshop and the printer driver have limited communication, you have to set the printer and 16-bit printing in two places, Photoshop cannot turn off the driver's colour management and the printer driver cannot select the appropriate colour profile for you.

Your printer driver may have a different interface from the one shown here. Check with your printer manufacturer for additional information on using its driver.

1. Choose your printer from the Print menu.

2. When available, tick Send 16-bit Data.

3. Use the orientation buttons to rotate the image, if necessary.

4. Click Print Settings... to open the print driver dialogue box.

5. In the **Epson** Print dialogue box, select your printer and paper size from the menus. The paper size selection also determines which path to load the paper through. Use the Manual – Roll size options to feed stiffer paper and rolls through the alternative slot.

6. Select Print Settings from the menu in the middle of the dialogue box. (If you don't see the menu, click the button with the triangle to expand the dialogue box.)

7. Set the media type to match the kind of paper you are using. (If you are not sure which media type is best to use, check with your paper's manufacturer.)

8. Click Advanced Color Settings for advice on which profile to use for colour management and then click Basic to return to the main screen.

9 Select Color and tick 16 bit/Channel if you are printing from a 16-bit file.

10 Important: set Color Settings to Off (No Color Adjustment) because Photoshop is managing the colour. If your print comes out with a strong magenta cast, it's probably because you didn't turn this setting off.

11 Choose a Print Quality setting. Photo – 1440dpi works best for most situations. (You will be hard pressed to see a difference if you choose SuperPhoto – 2880 dpi, though it uses more ink.)

12 Optional: tick High Speed for faster bidirectional printing.

13 Click Save to store your settings in the document.

ALERT: If you see fine horizontal lines in the print, try turning off the High Speed setting and reprinting. Some papers require special paper feed and some require that the platen gap is adjusted. See your printer's documentation for more details.

Set page layout in Photoshop

Use the page layout parameters to precisely position the image on the page.

1 Use the menu at the top of the Print dialogue box to select your printer.

2 Enter the number of copies.

3 If your image is orientated incorrectly, use the rotation buttons to reorientate it.

4 To move your image off-centre, untick Center Image. Click in the fields and type values or use the arrow keys to move the image on the page.

5 You can tick Scale to Fit Media to shrink your image if you have not resized or resampled prior to printing.

6 To scale or position your image visually, put a tick mark next to Bounding Box to show the handles. Drag the edges or the corners of the box to scale the image. Drag inside the box to reposition on the page.

ALERT: If you use scaling, watch out for print resolutions that are substantially less than 150 dpi. Take note of the indicated print resolution and use that to resize later.

Set colour management in Photoshop

The colour management parameters are essential for getting quality colour out of your printer.

1 Make sure that the circle next to Document is filled in.

2 Select Photoshop Manages Colors from the Color Handling menu. The alert reminding you to disable the printer's colour management relates to step 11 in the section Edit and save Print Settings earlier in this chapter.

3 In the Printer Profile menu, select a profile that matches your printer and paper combination. You can use the profile recommended by the Epson driver.

4 Choose either Relative Colorimetric or Perceptual for the Rendering Intent. Even though Perceptual can shift colours in your image more, colour gradients are less likely to break down. Relative Colorimetric is not recommended if you are printing a ProPhoto RGB document – it will likely cause gradients to posterise into bands of flat colour.

5 If you have been following the workflow outlined at the beginning of this chapter, this is the final step before sending the job off to the printer. Review your settings and press Print to start the print job.

HOT TIP: When you hover the mouse pointer over the items in the Color Management system, a description of their function appears in the box at the bottom of the dialogue box, as shown for Relative Colorimetric in the Rendering Intent section.

Color Management ▼

● Document
 (Profile: Adobe RGB (1998)) **1**

○ Proof
 (Profile: N/A)

Color Handling:

Photoshop Manages Colors **2**

⚠ Remember to disable the printer's color management in the print settings dialog box.

Printer Profile:

SPR2880 Premium Luster **3**

Rendering Intent:

Relative Colorimetric **4**

☐ Black Point Compensation

Proof Setup:

Current Custom Setup

☐ Simulate Paper Color

☑ Simulate Black Ink

Compares the white of the source color space to that of the destination color space and shifts all colors accordingly. Out-of-gamut colors are shifted to the closest reproducible color in the destination color space. Relative colorimetric preserves more of the original colors in an image than Perceptual.

5

Done Print

Print in black and white from Photoshop

Printing in black and white is very similar to printing in colour and works the same, whether you are printing a greyscale document or a converted colour image containing a Black & White adjustment layer. Of course with a Black & White layer, you can print black and white and colour versions of the image from the same file.

When printing in black and white, the difference in the process comes down to the settings you specify in the printer driver. This example shows the printer driver of the Epson R2880 printer, but there are other printers that have similar features and capabilities.

The first part of this chapter discussed how to establish the page layout and colour management settings in detail. That process is the same for black and white. The print settings are established as follows.

1 Click Print Settings... to open the Print dialogue box.

2 Select Print Settings from the menu in the middle of the dialogue box.

3 Select the appropriate media type.

4 Choose Grayscale from the Color menu.

5 Set the Print Quality – here, Photo – 1440dpi.

6 Optional: tick High Speed.

7 Click Save.

 HOT TIP: Epson's print drivers have two black and white modes: Grayscale and Advanced Black and White mode. The Advanced mode provides a way of colour-toning your black and white images, but it is better to do such toning in Photoshop, where you have more control and more options.

SEE ALSO: For details on converting colour to black and white, see Chapter 4.

Use the Print module in Lightroom

Like Photoshop, Lightroom can colour-manage printing, but Lightroom also gives you a sophisticated and flexible tool for printing multiple photographs. Using templates, photos can be printed on individual sheets or combined on a single page. Click on Print on the upper right side of the Lightroom window to switch to the Print module.

This example shows printing on the Epson R2880 printer from a Mac, but operating system dialogues and print drivers vary. Also, Lightroom's Page Setup and Print Settings buttons are combined into one on Windows. Regardless of your computer and operating system, the same principles apply, even though the screens may be different on your computer.

1 Use the Template Browser on the left side of the window and click to select a template, for example Maximize Size, (1) 8 × 10, or 5 × 8 Contact Sheet.

2 The Filmstrip will retain the selection you made in the Library module or you can use the Collections panel and Filmstrip to select photos to print.

3 Click the Page Setup button in the lower left to open the operating system's Page Setup dialogue box. Specify your printer and paper format, then click OK to close the dialogue box. (In Windows, choose a page size from the Size menu.)

4 Click Print Settings on the lower left side of the window to open the print driver dialogue box and navigate to the Color Settings section.

- In Color Settings, choose Off (No Color Adjustment) if Lightroom is managing colours.
- If the printer is managing colours, most can manage sRGB, but some can also manage Adobe RGB. Choose a colour space that matches your printer's capabilities.
- Select Print Quality. High Speed is optional. Click Save to close the dialogue box.

SEE ALSO: See Edit and save Print Settings earlier in this chapter for more details on using the Print Settings dialogue box.

HOT TIP: You can save any customisation that you've done in the Print module as a template. Click the plus sign (+) at the top of the Template Browser panel to open a dialogue box to name and save your settings.

5. Use the Layout panel on the right side to customise a preselected template and control the size and position of the image on the page.

6. Go to the Print job panel at the bottom of the panels on the right side. You may need to scroll down and use the disclosure triangle to see the controls.

7. Recommended: leave Print Resolution ticked and set to 240ppi.

8. Set Print Sharpening according to your tastes.

9. In the Color Management section of the panel, select either Managed by Printer, a colour profile or Other... from the menu.

 - Use Other... to manage the colour profiles that appear in the Color Management menu. Tick or untick items to add or remove them from the menu and then click OK.

10. If Lightroom is managing colours, select the Perceptual Rendering Intent to maintain tonal transitions. Alternatively, select Relative to minimise colour shifts, though it has a greater risk of problems with tonal transitions in gradients like skies and clouds.

11. Click Print One to send the job to the printer or click Print... to revisit the printer driver's dialogue box from step 4 before the print job starts.

7 Use online print services

Introduction

Online services offer an extremely broad range of products that they can print photos on. This chapter shows only a small sampling of the range of possibilities of transforming your photos into gifts and promotional items, but they should make it clear that it's fairly simple to set up an account, upload images, then design and order your own mugs, T-shirts, mousemats and so on. Most of the services allow you to do your designs interactively, showing an onscreen preview.

Beyond printing a photo on an object, photo books are a popular way to share images. You can make your own high-quality coffee-table book or portfolio easily. We'll look at just one of the book-making processes from Blurb, because it is well known and their BookSmart software has advantages over online book-making tools. Photobook UK has similar design software that you can download and offers distinctive handmade bindings.

Set up a Shutterfly account and upload photos

Shutterfly is a popular online source of photo-related products and services. Beyond printing services, it offers a wide range of other photo items, including calendars, photo gifts and resources for digital scrapbooking. Shutterfly makes it convenient to upload images to albums and then use photos from them in projects that you manage from the My Shutterfly and My Pictures pages.

1 Go to www.shutterfly.com and click on Sign up to create an account. Fill in the details, then click Join now.

2 Click Upload to open the Upload dialogue box.

3 Click Choose files… The system dialogue box will open, allowing you to select files from your computer. The files you select will appear in the dialogue list.

4 Click an item in the list to rename it or remove it from the list.

5 Name your album and click the circle next to Create new album or choose an existing album from the menu.

6 To transfer your files, click Start. When the upload has been completed, you'll see buttons to upload more or view pictures.

7 Click View pictures to review your images.

> **? DID YOU KNOW?**
>
> If you are interested in digital scrapbooking, Shutterfly has an extensive collection of resources for you. Go to www.shutterfly.typepad.com to find out more.

Become a member

First name
Louis

Last name
Benjamin

Email
lou@

Password

Confirm password

☐ Yes, I accept the Shutterfly terms and conditions.

Join now

Already a member? Sign in.

1

shutterfly Welcome Louis

2

Upload pictures

① Choose pictures on your computer to upload

Choose files... **3** Rename Selected | Remove Selected **4**

Title	Size
DSC_0318.jpg	0.67 MB
DSC_0324.jpg	0.52 MB
C_0440(antique chair).jpg	
(arved arm).jpg	
13 files	8.09 MB

② Choose where to upload to **5**

● Create new album: ○ Upload to existing album:

My_First_Album New Album ▼

6 **Start** **Cancel**

Welcome and thank you for choosing Shutterfly

Tell amazing stories with your photos. It's easy to add them to your account.

Take pictures ⇒ Upload them to shutterfly.com ⇒ Turn them into cards, photo books and gifts

Upload **2**

Upload completed

13 pictures were added to: My_First_Album

What would you like to do now? **7**

6 **Upload more** **View pictures**

HOT TIP: Shutterfly only accepts JPEG files. Keep the quality setting high and upload high-resolution images to use them for projects like mugs and T-shirts. To make uploading simpler, you may want to prepare your files specifically for Shutterfly and export them to a single folder.

Order photo prints on Shutterfly

Shutterfly makes it easy to upload your photos and order prints.

1 Log in to www.shutterfly.com and click on My Pictures. Click on an album to view its contents.

2 In My Pictures, click one or more thumbnails to select or untick the box in the upper left corner of the thumbnails to deselect them.

3 Click Order Prints to go to the size selection page.

4 Enter quantity, size and finish specifications (1, 4 × 6 glossy, for example). You can also specify a back-of-print message.

5 Click Next in the upper right corner of the screen to continue to the shipping information page.

6 Enter your shipping information and click Next to go to your shopping cart.

7 On the shopping cart page, click Go to Checkout to give your payment details and click Place my order now to complete your order.

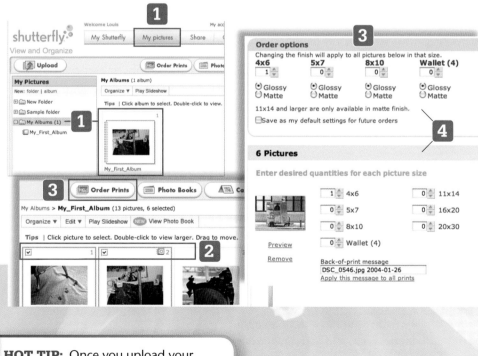

HOT TIP: Once you upload your images to Shutterfly, they are available for use in any Shutterfly photo project.

Create a photo mug on Shutterfly

Once you have uploaded some photos to Shutterfly, you can use them to create a range of photographic gifts and stationery. From the home page, you can click on My Shutterfly to manage your photo albums, work on projects and share photos online.

1 Go to www.shutterfly.com and click on Photo Gifts in the second row of the menu at the top of the page.

2 Under Photo Mugs, click Go to view a selection of styles. Click Go beneath the style that you like.

3 Your style may have additional options. Click the appropriate link (such as 11oz Mug White) to enter the editor.

4 Click to select a layout and then click Get pictures to view photos on the Lightbox.

5 Click to select photos. You can also click the Upload button to add more photos.

6 Click Add to Mug to place the photo. If your design allows more photos or you'd like to try different photos for your design, you can click Yes when you see the Add additional pictures message. When you're done, click No and you'll be returned to the editor. Your picture(s) will appear at the bottom of the editor window.

7 Drag your photo to the box to place it on the mug.

8 Click the photo area to edit. You can crop, rotate and apply or remove effects. Click Done to return to the mug editor.

9 Click Preview to see a 3D simulation of your mug. Use the slider to rotate the preview.

10 Click Save to name and store your design. Click Order to purchase or click the Shutterfly logo to return to the home page.

ALERT: Use high-resolution JPEG files for your mug. A single-image mug has a print area that measures 10 inches wide and 3.75 inches tall. If the resolution of your image is too low, Shutterfly will not allow you to place an order, because the print quality will likely be unsatisfactory.

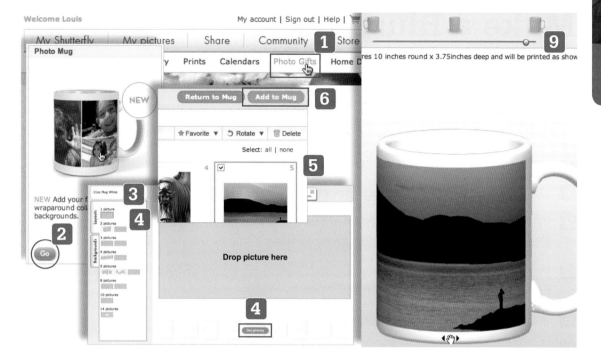

Make a Blurb book

Blurb books are leaders in online book publishing because they offer both high quality and superior workflows. You can publish photo-only books with their online interface or create books with photos and text using their BookSmart software for the Mac and Windows.

1. Go to www.blurb.com and click MAKE A BOOK.

2. On the Choose a Bookmaking Tool page, click Blurb BookSmart® and register.

3. When you have completed the registration, you'll go to the download page. Click Download Blurb BookSmart for your platform.

4. Install the downloaded BookSmart application on your computer, then go to BookSmart on your computer and open it.

5. In BookSmart, click Start a new book.

6. Choose a size and then click Continue.

7. Choose a layout and then click Continue for the guided option or Start Book Now to do your own book from scratch. (We'll continue with the guided option.)

8. On the Get Photos page, select where your photos are coming from. Select Your Computer to use your own files and then click the Add from computer button to use the system dialogue box and select one or more files to add. If you need to add more photos, click Add more from computer until you have what you need. Click Continue when you have finished.

9. Decide whether to autoflow your photos or use drag and drop. Click Continue.

10. Choose a page theme and then click Continue.

11. You'll be taken to the layout editing environment, where you can rearrange photos and pages, change layouts and add decorative elements. Select from the three cover options.

? DID YOU KNOW?

The website www.photobookuk.com also offers a service for printing high-quality books. It sets itself apart by offering handmade books with beautiful bindings. You can create books using its free Photobook Designer software, which is comparable to Blurb's BookSmart.

12 Drag and drop images to pages to place them. BookSmart warns you if the resolution of your images is too low.

13 Click Preview Book to check your work. Click Edit book to continue editing or click Order book to purchase.

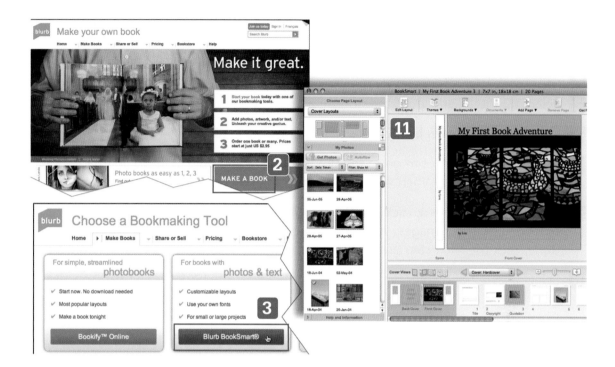

HOT TIP: Blurb also has a simpler online book design option called Bookify and a professional PDF to book workflow option that uses InDesign templates and allows full design control along with colour management.

Create a business card at MOO

You can create business, cards, postcards, greeting cards and sticker books on the MOO website. The ideas section of the site offers inspiration, tips, a blog and a newsletter. MOO business cards are high-quality heavy stock and its eco-friendly green stock is 100 per cent recycled. MOO also has an innovative printing capability: when you print a 50-card pack, you can literally print a different photo on each card.

1 Upload your photos, then go to http://uk.moo.com

2 Select Business Cards from the Choose a product menu.

3 Click Upload my own files to begin designing your cards.

4 Click Upload your files to go to the uploader page and upload up to 50 images for Side A of your card. When you're done, click the Next step button.

5 On the preview screen, click Edit this image to crop, zoom or rotate. If you've uploaded multiple images, you can also tick Don't use this design. When you're done, click the Next step button.

6 Select a layout and enter type or upload artwork for the back of the card. You also have the option to apply colour to the text or the background of the card. Click Check Preview to see what your card looks like before proceeding. When you're done, click the Next step button.

7 The preview screen will appear. Click Edit this image or Edit details to go back. Review the Quick checklist and click the Next step button when you're ready.

8 Select your paper stock.

9 Choose your quantity and click Add to Cart. You'll see a couple of opportunities for add-on sales before continuing to the checkout process.

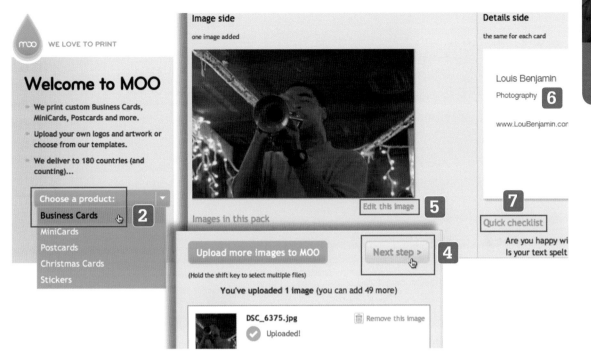

HOT TIP: MOO's recommended format for business card photos is 1039 × 697 pixel JPEG files. You'll probably want to crop and prepare images specifically for uploading for this purpose.

8 Share images via the Internet

Introduction

Aside from browsers, apps on mobile phones and on our computers are already very Web-savvy. Picasa, Lightroom, Bridge, and many other applications are all able to upload files or even whole Web pages with the click of a single button. The speed and ease of sharing images on the Web is impressive, and the Web is still evolving. As GPS-enabled phones are becoming more commonplace, location-based sharing is just coming into its own.

In this chapter we'll look at just a few examples of how you can share your photos via the Web, from an automation trick that makes e-mailing photos even simpler to blogging and maintaining Web galleries. Then, we'll look at how maps and image sharing can go together.

Set Lightroom for streamlined e-mail attachments

Attaching images to e-mails can involve several tedious steps, especially if you have to format and export the images first. In Chapter 5, we saw how you can create presets to export files from Lightroom in a streamlined fashion. In this example, we'll look at creating a preset that automates the process of exporting and attaching files to a new e-mail and switching to your e-mail application.

1. Locate your mail application in Finder or Windows Explorer, then make an alias or shortcut to the application. Place the alias/shortcut on your desktop. We'll use it at the end of this process.

2. Switch to Lightroom and select at least one image in the Library module. Click the Export button to define your export parameters. The Export dialogue box will open.

3. In the Export Location section, click the Choose button to specify where your files will be saved before they are attached to the e-mail. In this example, the files are being placed in a folder called Lr to Mail.

4. In the File Settings section, set the format to JPEG, the colour space to sRGB and choose a quality setting.

5. Customise the Sizing, Output Sharpening, Metadata and Watermarking sections below the File Settings section according to your needs.

6. In the Post-Processing section, select Go to Export Actions Folder Now from the menu. A window will open in Finder or Windows Explorer, with the Export Actions folder selected.

7. Move the alias/shortcut created in step 1 into this folder and return to Lightroom.

8. Your mail application should now appear in the After Export menu – select it.

9 Click Add to create a new preset. Enter a name for your preset – here, 1000px to mail – and click Create.

10 Your preset is ready to use. Click Export to take it for a test-drive.

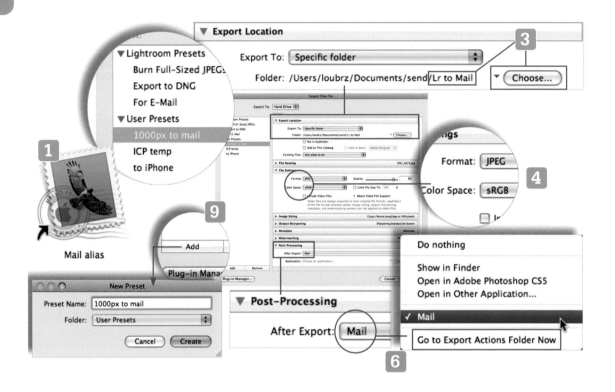

A look at Tumblr

The next few examples will show how you can set up a free Tumblr account and start sharing photos and more online. Tumblr is a popular site for creating blogs (short for Web logs), known for its simplicity, ease of use and clean interface. You really don't have to know much about blogging to use it.

The company behind Tumblr describes it as 'the easiest way to share the things you do, find, love, think, or create'. Older blogging platforms like WordPress, TypePad and Blogger are known for their flexibility and publishing power, but that power comes at a cost. They are substantially more complicated to set up and use. Signing up for a Tumblr account is quick and easy, and its stripped-down posting process allows you to share your photos, text and other content quickly and easily. Tumblr allows you to post photos and other content to your blog from a Web browser, via e-mail or even from AIM. You can use a smartphone to send text, images or video or even call in an audio post. Seconds after you snap a photo with your smartphone, it can be on your Tumblr blog.

You can think of Tumblr as an engine for sharing information and building communities. Not only can you post your own photos for the world to see but you can also easily promote work that you appreciate from other people and they can promote you. With a few clicks, you can add entries from other Tumblr blogs to your own or post links to interesting Web pages on other sites – a process known as reblogging. When the people you connect with begin to reblog your posts, they become viral; your work can spread to hundreds of outlets. Tumblr can also save you work by automatically feeding your posts to your Facebook and Twitter accounts. You can also add a handy tool called a bookmarklet to your browser's bookmark bar. With the bookmarklet, you can add content from any Web page you are visiting simply by clicking on the Share on Tumblr bookmarklet.

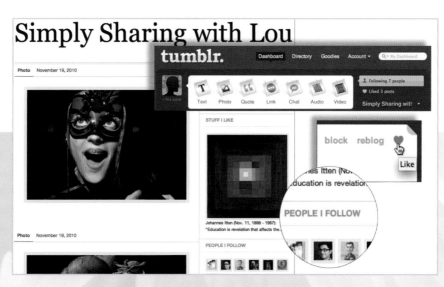

Set up a Tumblr account

Setting up a Tumblr account is a simple matter of entering your login information and selecting a URL (Web address). In the next example, we'll look at adding content to your blog.

1 Go to www.tumblr.com, then select a URL and password. Enter them along with your e-mail address.

2 Click the sign up button. If the URL is already taken, you'll be prompted to pick a different one.

3 When your account has been created, you'll land at the Dashboard page.

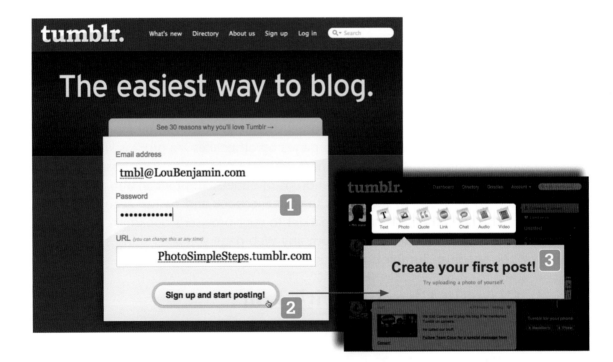

Upload your first photo to Tumblr

Whenever you log into Tumblr, you'll land at the Dashboard page. From here, you can add photos, text, videos and more. Just click on one of the icons at the top of the Dashboard to begin a new post.

When you first create an account, Tumblr will prompt you to post a photo. The first time you upload a photo, you'll be prompted to customise your blog when the upload has been completed. In the next example, you'll choose a theme and title for your blog.

1 Click the Photo icon on the menu bar.

2 Click the Choose File button and use your operating system's dialogue box to select a photo on your computer's hard drive. The filename will appear next to the button when you are done.

3 Optional: enter a caption and tags for your photo.

4 Optonal: click Preview to see a preview of your post in a separate window. Close the window when you're done reviewing your work and make any edits you may need.

5 Click Create post to upload the photo to your Tumblr blog.

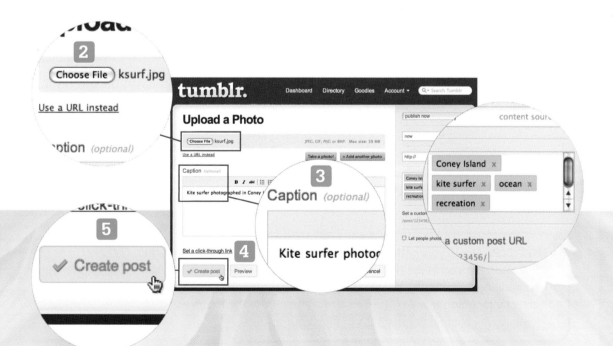

Choose a theme and give your Tumblr blog a title

Your blog is almost ready to share with the world. In this example, you'll choose a 'skin' for your blog and give it a title. There are some other customisation options to consider, as well.

1 Enter a title for your blog.

2 Optional: click Choose File and browse to upload a portrait photo. This image will be used as your avatar.

3 Click Show all appearance options to continue to the Customize page.

4 Click Theme to select a look for your blog. Scroll through the list of themes and click on one that you like.

5 Optional: click Appearance to edit text colours, upload a header image and manage widgets that appear on your page.

6 Optional: click Community for options to allow replies to your posts, let people ask questions or even submit posts.

7 Click Advanced to control special options. If your blog contains NSFW (not safe for work) content, tick the box in the Directory section.

8 When you are happy with your settings, click the SAVE + CLOSE button. You'll see your first post on the Dashboard with options to delete or edit it.

9 A link appears below the title of your blog near the top of the column on the right. Click the link to view your blog.

HOT TIP: Any of your settings can be revised at any time by clicking on the Customize icon in the right-hand column of your Dashboard. You can find additional themes by browsing the Theme Garden. You can access it directly by going to www.tumblr.com/themes – use the Featured, Premium, Recent and Popular tabs to filter your options.

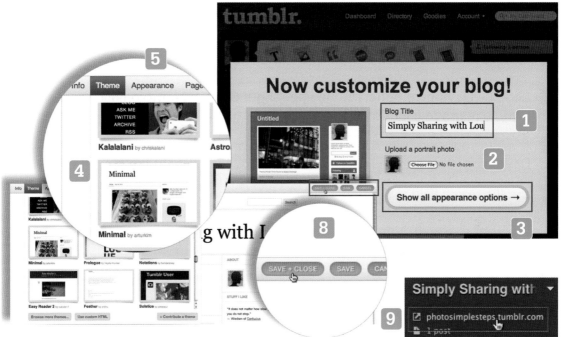

Navigate on Tumblr

Your blog is now ready to share with the world and you're ready to explore Tumblr.

1 Click the Dashboard button in the upper right corner of any blog, including your own, to return to your Dashboard.

2 A link to your own blog appears near the top of the right-hand column of the Dashboard. Click it to revisit your blog or click your avatar at the top left corner.

3 Use the search field in the upper right corner of the Dashboard to find posts by keyword or phrase. Click the magnifying glass icon to show a menu and select how you want to search. Notice that you can search all of Tumblr, any posts listed on your Dashboard, your own posts or Tumblr's Help Docs.

4 To search, select a method, type a keyword phrase into the search field and then hit Return/Enter. Results appear in the list area with the poster's avatar on the left and the contents of the post in the middle.

5 You can track the tags that you use frequently. The phrase you entered in the search field appears under the label Tracked Tags in the right-hand column immediately after your search. When you put the mouse pointer over a tag, the word save will appear to the right of it. Click on save to remember the tag. Once a tag is saved, click on the tag to repeat the search or click the X that appears to the right of it to remove it from the Tracked Tags list.

6 In the Dashboard results list, place your mouse pointer over a post and the upper right corner will turn down. Click that corner to go to the post and see it in its original format.

7 Click an avatar on the left side of the results list to visit that blog.

8 The Radar and Recommended blogs widgets appear beneath the Tracked Tags in the right-hand column. You can click on those items to visit other blogs.

9 From the Dashboard, you can also click on Directory to browse staff picks and recommended blogs.

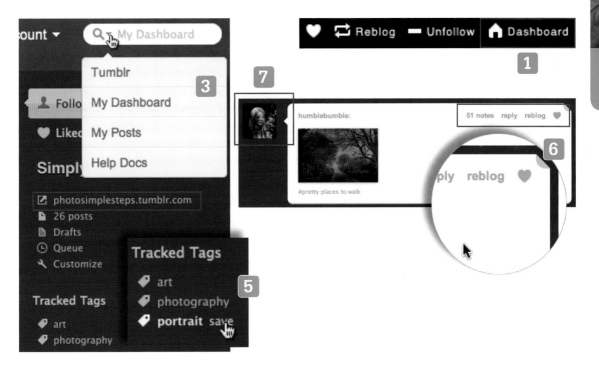

HOT TIP: Don't be surprised if you click on something in a Tumblr blog and find yourself on another site, such as Flickr. Lots of Tumblr blogs include photos or text that links to other sites. When you explore Tumblr, you'll find yourself exploring the whole Web.

Create additional Tumblr posts

You can create posts from your Dashboard by clicking on the icons at the top of the page or use the bookmarklet to create posts while browsing other Web pages. The bookmarklet can capture selected text, links, photos and other content from the Web page you are currently viewing.

1 Click the icons on the Dashboard to add a post.

2 Alternatively, install the bookmarklet on your bookmarks bar and use it to blog content from Web pages as you browse them.

3 Use the Publishing options menu to determine how the post will appear on your blog. (In the bookmarklet, click on the Advanced tab to see the Publishing options menu.)

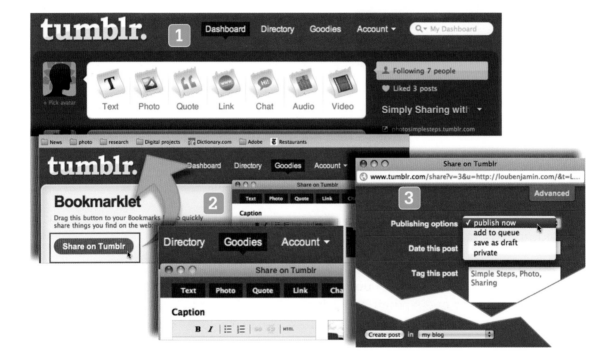

HOT TIP: Once you have composed your post, in addition to saving a draft or setting the Publishing option, you can use the following options:

- publish now makes the post available to all viewers immediately
- add to queue delays the post for later publication – it will then automatically appear according to your settings or you can look at the queue and post entries on demand
- private adds the post to your blog, but keeps it invisible to others.

Post with the Tumblr app

If you have an iPhone or other smartphone, you can post to Tumblr from it. While the screens in the Tumblr app look somewhat different from what you see on your Web browser, the functionality is essentially the same. In this example, we'll go through the steps of posting a photo to the Tumblr blog you set up earlier in this chapter.

When you start the Tumblr app for the first time, you'll be at the Settings screen, where you enter your account information. You can even sign up for a new Tumblr account via your phone. Once the correct login and password are given, you'll see a message saying 'Account Valid' and the indicator on the screen will turn green. Tap Done. You can return to this screen by tapping the gear icon in the upper right corner of the post screen.

1. Tap Post at the bottom of the screen to begin a post.

2. Tap Photo to create a photo post.

3. Tap a button to specify where the photo is coming from. For this example, tap Choose existing photo.

4. Tap a photo album (Camera Roll or Photo Library, for example) and navigate to a photo.

5. Tap a photo to select it. The photo will appear in your post.

6. Optional: tap the photo in the post to return to the selection process.

7. Optional: tap the Description and Click through URL fields to enter text or a Web address as needed.

8. Optional: tap the grey bar that reads Open advanced options at the bottom of the form. Use the controls to post to any other blogs you have created with the account, use the queue, draft and private post options, add keywords and set a custom post URL. Tap the grey bar that says Close advanced options to return to the main Photo screen.

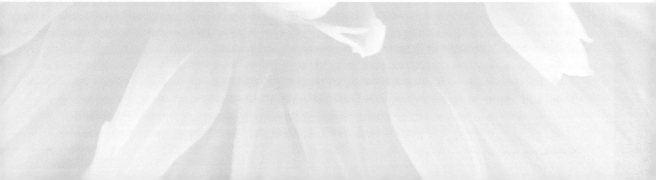

9 Tap Post when you're ready.

10 You'll be taken to the Dashboard after your post has been completed. Tap edit to revise it or tap the X to delete the post.

Network your Tumblr blog

Once you post something on Tumblr, it's time to connect with others. You can keep tabs on other Tumblr blogs by following them. If you see something that you like, you can register your vote of approval, reblog it, post a note or answer a query. All of these activities increase your presence on Tumblr. The owners of the blogs you follow may follow yours in turn. When others reblog your posts, they give your items a wider audience. Tagging your entries increases your visibility, too. When it comes to connecting with others, showing up is half the battle.

1 When you find a blog that looks interesting, click Follow in the upper right corner of the page to add it to your blog's People I Follow list. If you decide later that you don't want to follow the blog any more, the same button will have become Unfollow.

HOT TIP: Reblogging is a good way to share ideas, but don't forget to post your own original entries on a regular basis.

2 When you follow people, their recent posts will appear on your Dashboard.

3 Click an avatar in any blog's People I Follow list to visit a blog.

4 You can register that you like a blog post by clicking its heart icon. That post will show up in your Stuff I Like list.

5 Click Notes on a post to see a list of the responses to it, including reblogs, likes, answers and replies.

6 Some posts will show a camera icon to indicate that you can reply to the message with a photo of your own. Click the icon and use the system's dialogue box to select a photo to upload.

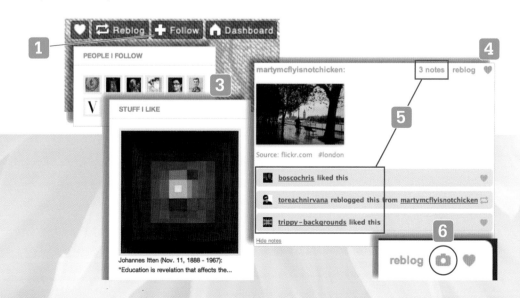

Manage your Tumblr blog

As you explore and add content to your blog, you'll probably want to update and refine it. Here are some ways to do that. You manage your blog from the Dashboard, so click the Dashboard button in the upper right corner of any blog, including your own, to go to your Dashboard. Use the menu at the top of the page and the column on the right to manage your content and customise your blog.

1 Use the Account menu at the top of the Dashboard to edit preferences, get help or log out.

2 Select Preferences from the Account menu. Click Customize your blog on the upper right to enter the Customize module.

- Click the buttons on the bar at the top of the Customize module to access dropdown panels. With these panels, you can edit your basic info, change your theme, add static pages or turn on community features like replies and asking questions.

- The Services and Advanced panels allow you to do things like automatically feed your posts to Facebook and Twitter. If you are familiar with RSS feeds, the Services and Advanced panels also have controls for managing them.

- Click SAVE + CLOSE to apply your changes and return to the Dashboard.

3 On the Dashboard, click the icons marked Posts, Drafts or Queue in the right-hand column to select and view them on the Dashboard. You can save a draft or queue a post with the menu in the Add dialogue box.

4 The upper right corner of Dashboard posts will turn down when you place the cursor over them. Click the corner to go to the original post.

5 Click the Drafts or Queue icons to review any posts that are pending.

- After you have edited a draft, you can publish it immediately or queue it.

- Buttons in each queued post allow you to delete, edit, or re-sequence when they will be published.
- Use the menus at the top of the Queue and click the Save button to control how often posts are automatically published.
- The scheduled date and time of publication are shown to the left of a queued post. Drag the double-headed arrow to change the order of queued posts.

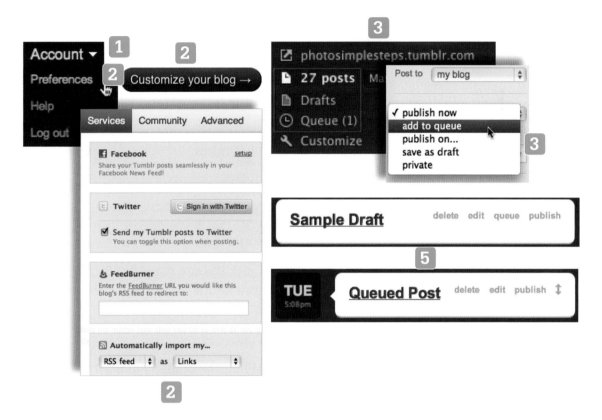

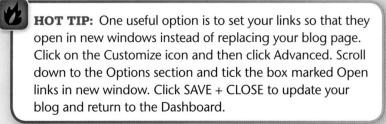

HOT TIP: One useful option is to set your links so that they open in new windows instead of replacing your blog page. Click on the Customize icon and then click Advanced. Scroll down to the Options section and tick the box marked Open links in new window. Click SAVE + CLOSE to update your blog and return to the Dashboard.

Set up a Picasa Web Albums account and upload photos

Once you establish an account, Picasa Web Albums can communicate with the Picasa application on your computer to make uploading Web albums a simple point and click operation. Just select images in Picasa and click the Upload button. The Picasa Web Albums site gives you 1GB of free space for your images. More space is available for a fee.

1 Go to www.picasaweb.google.com and click Create an Account or enter your Google login info. If prompted, read and accept the terms of service.

2 If prompted, enter a name you're comfortable sharing to create your Google profile. You'll arrive at the My Photos page in Picasa Web Albums.

3 Click the Launch Picasa button.

4 In the Picasa application, select a set of photos to share.

5 Click the Upload icon. If prompted, enter your login info.

6 In the Upload dialogue box, name your album, pick the size you want Picasa to make your uploaded photos and adjust access with the Visibility and Share With controls.

7 Click the Upload button.

8 The Upload manager will show your progress. When the upload has finished, the album you have created will appear in the Albums list at the upper left corner of Picasa.

9 Cick View Online to see them on your browser.

DID YOU KNOW?

The Export panel in Adobe Bridge and Publish Services in Lightroom are also designed to upload to online services such as Flickr and Facebook. Export plug-ins for Lightroom are available for MobileMe, Photoshelter, Zenfolio and others.

You can also build your own customised website. The Web module allows you to design and export Web galleries using HTML or Flash-based viewers like Airtight's SimpleViewer. You'll need to know more about Web hosting and site management (or have access to someone who does) to use this feature effectively.

Share photos with Picasa Web Albums

Once you have uploaded photos to Picasa Web Albums, you can share them in a number of ways. When you make albums public, anyone can see them, but if you use the Anyone with the link or Private settings, you can limit access to invited guests only.

1 Log into your Picasa Web Albums account.

2 Click the My Photos tab.

3 Click an album to view its contents.

4 In the menu bar above the album thumbnails, click Edit and select Album Properties from the menu to change its attributes, including its name and visibility (public/private) settings.

5 Use the panel on the right to share the album in various ways.

- Click Share to send an e-mail containing a link to the album.
- Use the buttons labelled 'Post on' to post your album to Google Buzz, Blogger or Twitter.
- Click Link to this album to display fields you can copy and paste into e-mails or Web pages to share the gallery.
- Link to this album also has a Reset secret link option. If the visibility for your gallery is set to Anyone with the link, clicking Reset secret link will generate a new secret link code and lock out anyone who received a previous secret link.

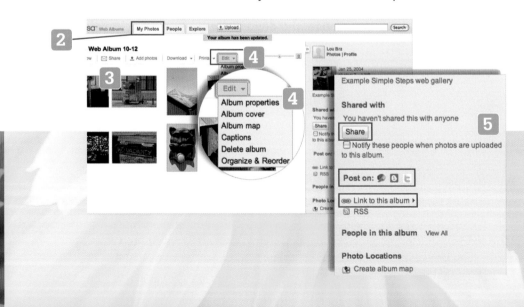

Put your photos on the map – literally – in Picasa or Picasa Web Albums

Google, Flickr and Facebook all have map-based photosharing applications (actually, Google has several) that can show a photo in the context of a map by reading geo-tags – map coordinates embedded in the photos. The Picasa application and Picasa Web Albums have equivalent tools for adding, editing or deleting geo-tags.

Many smartphones like the iPhone don't just contain cameras; their cameras are GPS-enabled. When you shoot a photo, they can automatically embed the map coordinates of their location at the time. Some digital SLRs will accept an add-on GPS receiver that will do the same thing.

1 You can use the Places feature in the Picasa application to add or remove location info before you upload photos to the Web.

- Click on a folder or album or select one or more photos to show location pins on the map.
- Type an address into the Search box at the bottom of the Places panel and hit Return/Enter to find the location. If you have images selected, Picasa will ask if you want to place the photos there. Click OK to place them.
- Click a map pin to see if multiple photos share the location, or to erase location information.

2 When you upload geo-tagged photos to Picasa Web Albums and select a photo, a small map in the right-hand panel will show a pin with the location of the photo.

- Click View map in the right-hand panel to switch to Map view and review the photos inside a larger map.
- In Map view, you can click Edit Map to enter Edit mode.

? DID YOU KNOW?

Picasa's Places feature is just one of many applications that can embed geo-tags. A number of software programs for Windows and the Mac allow you to read information from a GPS device to add geo-tags to your photos. Software like HoudahGeo (for Mac) can read map coordinates from a reference photo taken with your iPhone and apply those coordinates to photos from your SLR.

3 To place photos on the map, click Create album map in the right-hand panel, type a location into the Map your photos box, then click Go. The Map view will open in Edit mode with thumbnails of your photos in a panel on the left.

4 With the Map view in Edit mode, you can place photos on the map or move them.

- Click a thumbnail and then click a point on the map to place the photo.
- Drag a thumbnail onto the map to reposition it.
- Click a thumbnail onto the map to see a larger version of the image with its map coordinates.
- To strip map coordinates from a photo, click Remove from map.
- Enter a place in the Find location box and click Go to change locations.
- Click Done to save your changes and click Back to album view to return to the album.

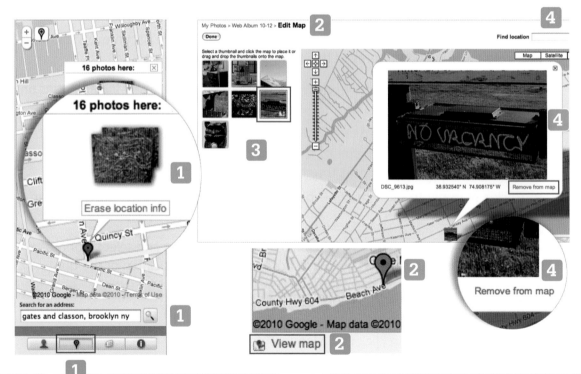

ALERT: While there are a number of benefits to automatically geo-tagging photos, there is a potential risk to uploading personal photos with embedded map coordinates in some cases. For example, you could unwittingly tell someone the location of your home. It's important to be aware of that when privacy is an issue and either turn off the geo-coding on your mobile phone's camera or remove the geo-tags from sensitive photos.

Use Panoramio – map-based social networking

Blogs and other online tools have allowed visitors to share and locate images by using abstract keywords for a long time, but Web applications and even smartphone apps are becoming increasingly location-based. With tools like Google's Panoramio, you can explore places and connect to people by browsing a map. Perhaps more important, you can use it to share your work and associate yourself with a particular place.

1 Go to www.panoramio.com and use your existing Google login or create a new account.

2 The first time you log in, choose a username and click Accept.

3 Upload up to 10 photos to start. Files can be up to 25MB or 50 megapixels. Click a Choose file button and use the system's dialogue box to select a file. Your filename will appear next to the button.

4 Click Upload to transfer the files.

- Use the Describe your photos dialogue box to add a title, tags and a comment to your photos.
- Click the plus sign (+) next to suggested keywords to add them.
- If your photo is not geo-coded, click Map this photo at the top of the dialogue box to place it on the map. Click Save to complete the process.
- When you click Map this photo, enter a location into the search box, then click Search. A map appears. If you enter an exact address, a pin will appear on the map. You can also click on the map to place or reposition the pin. Click Save position to finish.
- The geo-tagged photo appears, showing that it's mapped to a location. Click Change position to revise the location. Click Save to place the photo.

HOT TIP: Click Upload on the upper left side of any page to add more photos.

5 Your uploaded images appear in the Your photos section. Click a photo to switch to the photo page, which shows a larger view of the image with a map next to it. Thumbnails of nearby locations appear on the map and in a strip above the map. Click a thumbnail to view a photo.

- From this screen, click the photo to see it in its original size.
- The locations of the photos appear as a chain of breadcrumbs (such as World Map > USA > NY > Coney Island). Click one of the levels in the chain to view photos on the map.

6 Click Places to begin exploring by location. When you land on the Places page, you'll see photos from a randomly selected place.

- Click See next to select another location randomly.
- Use the breadcrumbs (here, Cool places > Europe > Blenheim Palace in England) to select a new location from a list.
- Click on a thumbnail to see a larger preview of the image in a balloon.
- Click the photo in the balloon to go to its photo page, click the byline to visit the contributor's profile or click the X at the top right of the box to close the balloon.
- Use the Like button, Add to favorites or Share photos.

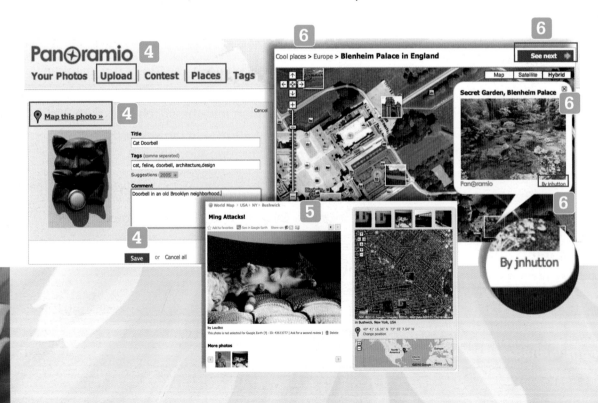

Top 10 digital photo problems solved

Problem 1: Importing into Lightroom is confusing

Part of the problem with Lightroom's import feature is that it's referred to as importing. Only some of the so-called importing options in Lightroom actually copy or move files and, when they do, the files are transferred to the location you specify, but they don't actually end up inside Lightroom.

Transcribe might be a better term than import for what Lightroom does. It essentially takes a snapshot of the files and folders that you are importing and adds that snapshot to its directory database. The database only refers to the files; when you browse in Lightroom, you're looking at the contents of Lightroom's database, not the files themselves.

Lightroom's Import dialogue box performs up to four related but distinct tasks in the order shown.

1 Optional: copy or move files to a new location (Copy and Move modes).

2 Optional: convert the files to DNG as it copies (Copy as DNG mode).

3 Add images to catalogue: capture the location, preview and metadata for the files and add them to its database. (All modes add images to the catalogue. Add does not copy or move files.)

4 Optional: back up the imported files to a second location, in Copy and Move modes only. It is available through the Make a Second Copy To option in the File Handling panel.

? **DID YOU KNOW?**

Which mode is the one to use?

- **Add** is the mode to use when you already have files organised on a drive that you want to catalogue, such as when you're switching to Lightroom from Bridge or some other image management tool. The catalogue records the images in their current location and folder structure and does not reorganise them. This applies to attached drives, network drives or uncatalogued folders on the same drive as your Lightroom catalogue.
- **Copy** and **Copy as DNG** are the only modes available when you are importing from your camera's memory card. That is so you can confirm the import went OK before you erase the card. The files are copied to the destination and catalogued in their new location. This applies to all potential sources of photos.
- The **Move** mode transfers files to a new location and deletes them from their original location before cataloguing them in the new location. This applies to any image source other than a camera's memory card.

Problem 2: Folders in Lightroom don't match what's on my computer

If you change the contents of your folders outside Lightroom, you'll need to synchronise its catalogue to add files that were added or remove files that have been deleted after you catalogued the folders. When you synchronise, you have the option to use the Import dialogue box to preview the results.

- Control-click/right-click on the folder to display a menu and select Synchronize Folder...

- Tick the relevant boxes in the dialogue box that appears to determine which data will be synchronised. When importing new photos, you have the option to visit the Import dialogue box first to apply metadata, presets and so on and even opt *not* to import some.

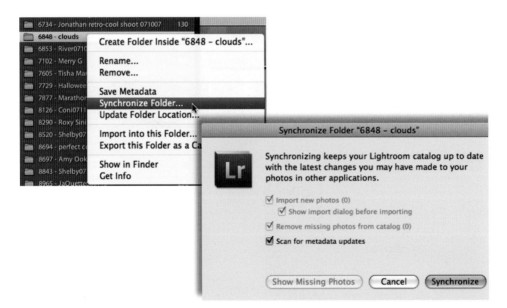

ALERT: If you move files or folders outside Lightroom, the references will be broken in Lightroom.

Problem 3: I can't see some of my photos in Lightroom

The Library filter has a lock icon. If the lock looks closed, the filter will remain active when you change sources, such as clicking on a new folder or collection. The result is that some of the images in the new source may be hidden.

● Click the lock icon to clear the filter when you change sources and click None on the Library Filter bar to clear the current filter.

Another possibility is that your photos may be hidden within stacks. You can group images into stacks by selecting two or more of them and hitting Command/Ctrl + G. Once the photos are stacked, the stack can be collapsed. When a stack is collapsed, a small numbered icon may appear in the upper left corner of the thumbnail, unless Thumbnail Badges are turned off in the Library View Options dialogue box.

● To turn the badges on, Select View, View Options from the menu bar and click on Grid view on the navigation bar at the top of the dialogue box. Tick the box marked Thumbnail Badges in the Cell Icons section of the dialogue box.

● Click on a stack and use the submenu under Photo, Stacking to manage it.

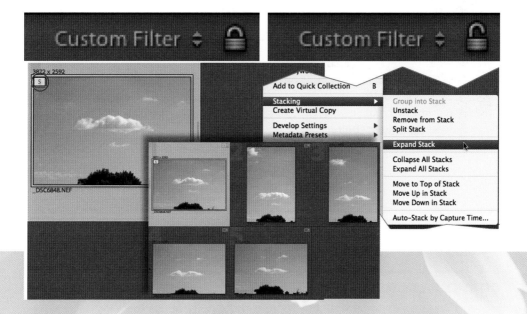

Problem 4: Double-clicking opens my photo in the wrong program

When you double-click on a document in the Mac's Finder or Windows Explorer, your operating system uses information in the file to decide which application to open it with. Each type of file opens in an assigned default application, but you can override this behaviour.

To override the default behaviour for an individual file, Control-click/right-click on the file to display a menu and select an application from the Open With submenu.

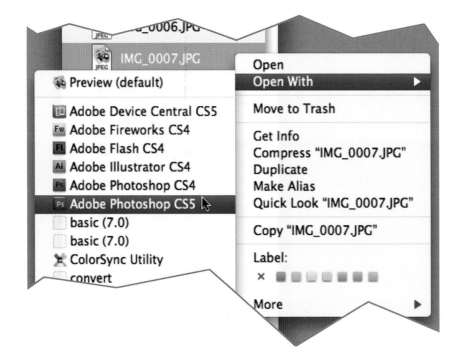

? DID YOU KNOW?

Mac and Windows both have slightly more complicated options to specify a different default application to open a particular type of file when you double-click. You can associate that application with individual files or with all files of that type. Consult your computer's help system or Apple's or Microsoft's support website for more details.

Problem 5: My prints look dark

A common problem with home printing is that computer screens come from the factory with brightness settings that make *movies* look great, but are way too bright for adjusting photos or making prints.

You can simply turn the brightness down, but it's better to adjust the brightness to a specific level of around 100 lumens. You can adjust your screen brightness as part of your calibration and profiling procedure.

Set the luminance level of my display to the following target value: 100

 SEE ALSO: See Set up your display for the best results in Chapter 6 for more details.

Problem 6: My prints are coming out with a strong magenta cast

One of the most common causes of this is having both your image-editing software *and* your printer driver managing colours.

1 If you set Photoshop, Elements, Lightroom and so on to manage colours using a paper profile, be sure to turn off colour management in the printer.

2 If the colour performance with the colour profile you are using is not very good, it may be because the profile is inaccurate. Try setting the output colour space to sRGB and ignore the reminder to switch off the printer's colour management.

3 If you can't find the option to switch off the printer's colour management, try printing to sRGB from Lightroom or Photoshop and let the printer driver manage colours.

Problem 7: My matt paper prints are coming out oddly coloured and mottled

Most matt printing papers have one side that is treated to hold ink and a back that is not, but it's not always easy to see the difference between the two sides. Epson's Ultra Premium Presentation Paper Matte (formerly Enhanced Matte) is one example. When you print on the back of this paper, the colours can look bad.

The easiest way to tell the print side from the back is to stand in moderately bright light and gently curl the paper so that you can see both sides. The bright side is the side to print on. With Epson printers, you load the paper into the printer with the print side facing you.

Problem 8: I'm getting a message about a missing colour profile in Photoshop

If you open a file without a colour profile, the colours you see may be completely wrong. To address the problem, Photoshop displays the Missing Profile dialogue box so that you can assign a colour profile. If you pick the wrong colour profile, your colours will still be wrong but, as long as you don't also convert the document to the working space, that's not a problem because you can assign a different profile after you open it. This example assumes the working colour space is Adobe RGB.

1 If you know the file was created in the Adobe RGB space, click the circle next to Assign working RGB to do so.

2 If the file came from the Web, it's a good guess that it is an sRGB image. Click the circle next to Assign profile to select it and choose sRGB from the profile menu.

3 If you are not certain which is the right colour profile, do not tick the box and then convert document to working RGB. If you plan to convert to another colour space after you have finished editing, it is also not a good idea to convert to the working space. Converting can shift colours and degrade your image.

4 Click OK to open the image. If the colours look wrong, choose Edit, Assign Profile... from the menu bar. In the Assign Profile dialogue box, leave Preview ticked and click back and forth between Working RGB and Profile to see how the colours in your image change. Use the Profile menu to compare results for Adobe RGB, sRGB and ProPhoto RGB. Click OK when you have found the best result.

Problem 9: I'm getting a message about an embedded profile mismatch in Photoshop

If you set the appropriate option in your colour settings, whenever you open a file that has an embedded colour profile which does not match the working colour space, you will see the Embedded Profile Mismatch dialogue box. For example, with the working space set to Adobe RGB, when you open an sRGB or ProPhoto RGB image, you will see the dialogue box.

The choice you're being asked to make is whether you want to work in the colour space that the image defines or convert the colours to the working space. Using the embedded profile is generally the best approach, especially if you plan to convert to another colour space after you are done editing, since each time you convert colours, there is a chance you will get colour shifts.

If, instead, you choose to convert the colours, there is less of a downside when you convert to a larger colour space – that is, from sRGB to Adobe RGB or from Adobe RGB to ProPhoto RGB. Converting to a smaller colour space is more likely to degrade your image. The most problematic conversion would be to go from ProPhoto RGB to sRGB.

If your image is in sRGB and you plan to adjust colours and tones and simply use the file for printing, there is some benefit to upgrading the colour space to Adobe RGB. If you are opening a Web file to adjust it and then post it back on the Web, there is no reason to convert from sRGB to Adobe RGB and back to sRGB.

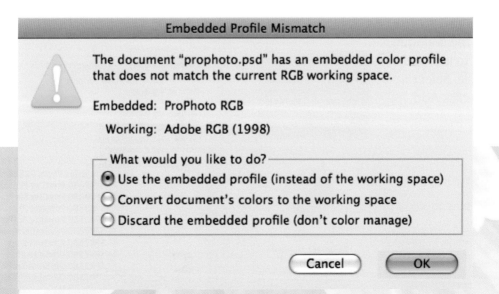

Problem 10: How do I install colour profiles?

Colour profiles – also known as ICC profiles – describe the colour capabilities of devices such as printers and display screens. Accurate profiles ensure that you get the best possible colour performance out of printers when colour management software such as Lightroom or Photoshop controls the translation of the colours in your image into the colour gamut of the printer.

When you install the software for many printers, new colour profiles will automatically be installed for you. Paper manufacturers (such as Hahnemühle, shown here) and print services also offer free colour profiles that you can download and install on your computer. To install colour profiles manually, you simply copy the file to one of the specified directories.

In Mac OS X, copy colour profiles to one of these locations:

● Macintosh HD/Library/ColorSync/Profiles
● Users/<your username>/Library/ColorSync/Profiles

In Windows XP or Vista, copy colour profiles to:

● Windows\system32\spool\drivers\color

In Windows 7, use the Color Management control panel as follows.

1 From the Start menu, select Control Panel and click on Color Management.

2 Click the All Profiles tab and then click Add.

3 Use the dialogue box to locate the profile. Select it and click Add.

4 Click Close.

Use your computer with confidence

Office 2010	Excel 2010	Word 2010	Powerpoint 2010	Windows 7
9780273736127	9780273736134	9780273736141	9780273736158	9780273729136
Excel 2007	Office 2007	Laptop Basics Windows 7 Edition	Computer Basics Windows 7 edition	Windows Vista
9780273723547	9780273723554	9780273736806	9780273736844	9780273723493
Laptop Basics	Mac Basics	Computer Basics	Photoshop CS5	Photoshop Elements 8
9780273723486	9780273729297	9780273723479	9780273736820	9780273734390
Web Design	Netbook Basics	Windows 7 for the Over 50s	Laptop Basics for the Over 50s	Computer Basics for the Over 50s
9780273723530	9780273734925	9780273729181	9780273729129	9780273729174

Practical. Simple. Fast.

PEARSON